TURNER

TURNER

GRAHAM REYNOLDS

HARRY N. ABRAMS. INC. *Publishers* NEW YORK

Contents

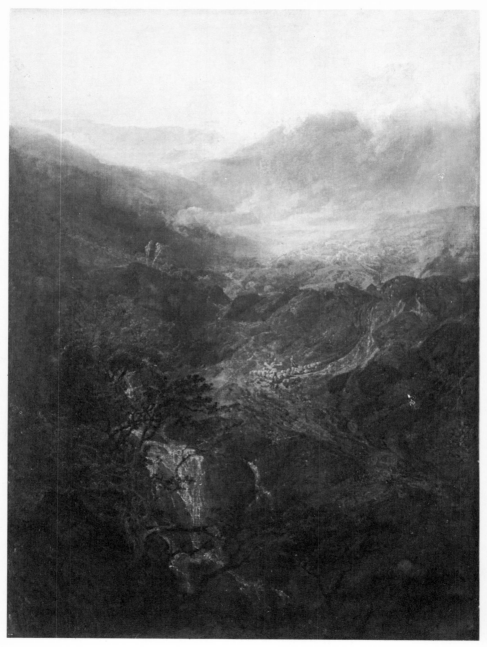

1 *Morning amongst the Coniston Fells, Cumberland* 1798

'Life's morning landscape'

Speaking in 1788, Sir Joshua Reynolds used the words, 'If ever
this nation should produce genius sufficient to acquire to us the
honourable distinction of an English school . . .' He was paying
a memorial tribute to Gainsborough, and prophesying that in
the event he envisaged, his great rival would be recognized
as one of the founders of a national school of painters. It is a
commonplace that his prediction has been fulfilled, and that
Reynolds, no less than Gainsborough, stands near the head of a
long and continuing line of native English artists. But it needed
courage to foresee such an event, and the means for its fulfilment
were outside the speaker's control, though he had done as much
as he could to further the cause by his support of the Royal
Academy. Had there been a complete lack of men gifted with
artistic talent, let alone genius, in the next generation there
would not have been the continuing momentum necessary to
maintain interest and development in painting and sculpture
throughout the country.

Accordingly, though his reserve may seem rather quaint in
retrospect, Reynolds was fully justified in using the hypothetical
mood for his inclusion of Gainsborough in a national Pantheon
of artists. The matter would soon be put to the test because at
this period, nearing the end of the eighteenth century, an
artistic generation endured about twenty years. The Royal
Academy had been founded for that length of time, and its
founder members would shortly be superseded by the young
men who would consolidate their success or render their effort
nugatory. The hopes which led to the Academy's foundation
were being assisted by the climate of opinion, by the increase
of patronage and by the efforts of publishers such as Boydell

and Macklin to commission paintings to illustrate literature. And as Reynolds spoke, Turner, the subject of this book, was making, at the age of thirteen, astonishingly precocious drawings. At the end of the following year he was enrolled as a student in the Royal Academy Schools and thus fairly embarked on the professional career as an artist from which he never deviated. That career, lasting over sixty years till the middle of the nineteenth century, is one of the main reasons why we have acquired 'the honourable distinction of an English school'.

Since his primary effort was to be in landscape painting, it is important to recall the state of this branch of art at the time when Turner began his career. He was heir to a substantial tradition, not alone from the continental schools, but from English forerunners. Their activity was of special significance to Turner, for the existence of any other artist with comparable or even lesser talent than his own was, if not an affront, a challenge to his competitive nature. He would paint in imitation of their style in order to gain the mastery over them. And, as he grew up into a world in which there was an accepted hierarchy of landscape painters, and a systematic way of looking at nature through their eyes, there was a full range for his receptive nature to absorb.

A main division in the landscape which was painted or collected at the end of the eighteenth century lay between that which was dominated by the Italian school and the alternative, which looked to the Low Countries. The landscape of Claude and Poussin, interpreting the facts of the Italian landscape in an emotional way, and projecting it into the classical past, has always exercised a dominating influence over English taste. To the collector who lived in the country and had been brought up on the classics, those idylls which were settings for the history and legends of Roman times had an irresistible appeal. But the decidedly down-to-earth flavour of Dutch landscape painting, based on peasant life and the realities of the town, were close enough to their own day-to-day observation. These patrons planted out their parks on principles culled from Claude,

but attended assemblies in towns familiar through Ostade and Van der Heyden.

Of the recent English painters who had looked to Italy for inspiration, the most spectacular were Richard Wilson, John Robert Cozens and, in his later work, Thomas Gainsborough. In view of Turner's own development it is significant that, quite apart from their subject-matter, these artists were all absorbed by and gifted at the rendering of the quality of light in landscape. In that they were true to the precept of Claude. As Constable said, 'the landscape of Gainsborough is soothing, tender and affecting . . . On looking at them we find tears in our eyes, and know not what brings them.' The other, Dutch, group, addicted to accustomed scenes of everyday life, was the more numerous throughout the eighteenth century. Besides Gainsborough in his earlier manner, it comprised a great number of the watercolour painters whose livelihood depended upon topography: Paul Sandby, Thomas Malton, Michael Angelo Rooker, and Samuel Hieronymus Grimm, all of whom were living when Turner started his career, are among them. It was the work of this group which first met Turner's eye, and provided him with the scaffolding from which he built all his later growth.

He was born on 23 April 1775, and given the names Joseph Mallord William Turner. His family called him William but he is now usually referred to by initials as J. M. W. Turner. A good deal has been made of his humble origins. It is true that his father, like Cotman's, was a hairdresser. But he was born into an age in which the relics of the traditions of patronage remained. The more privileged members of the community were ready to recognize talent, and were both willing and able to support it. An habitué of a tavern formerly housed in the cellars of Turner's birthplace, Richard Porson, is noted not only for his drunkenness but also for the fact that his talent was recognized in a village and generously supported throughout his life.

From his parents Turner learned, or inherited, the tradesman's respect for money which became the greatest help to the

furtherance of his career and the main prop of his artistic independence. His home life cannot have been a happy one, because his mother was subject to manic fits of anger, a condition which degenerated into insanity. She had to be put in Bethlehem Hospital in 1800, and died in a private asylum in 1804. To his father he was devoted, and one of the most touching features of his private life is the tenderness with which he cared for 'Daddy'. Not only had his father not put any obstruction in the path of his son's ambition; he positively encouraged it from the first appearance of his gift. This encouragement took the practical form of his exhibiting his son's drawings for sale in the window of his barber's shop. These he sold at prices ranging from one to three shillings and there seem to have been plenty of customers willing to buy.

Shortly after Turner's birth, his father moved to the other side of Maiden Lane, and here he worked till he was twenty-four. This house was described by Farington: 'the apartments to be sure, small and ill calculated for a painter'. But, though not grand, it was fairly roomy, and had two frontages. It stood at the corner of Hand Court and Maiden Lane; though the house no longer exists, the street does, running parallel to the Strand. The narrowness of the lane, even more of the court which formed its angle, may have made the rooms dark, but in other ways the situation of the house had some advantages and helped to mould Turner's career. For it was within three minutes' walk of the Thames, which was still the main highway for London's traffic. The nearest walk took Turner to the banks and steps just by the Savoy, where the river sweeps majestically to the right and provides the view of St Paul's dome riding above the streets, which has been a classic symbol of London since Canaletto and Samuel Scott painted it. In the other direction, and even nearer than the river, was Covent Garden market. Ruskin has evoked, in his imaginative comparison of the childhoods of Giorgione and Turner, the delight which the colourful jumble of this vast fruit and flower market must have given the young artist. He adduces as evidence of its

lasting power over his mind the last remark Turner made to him about St Gothard, 'that litter of stones which I endeavoured to represent'. But his liking for clutter may have had as much to do with the current theory of the picturesque – J. T. Smith's 'slatternry of tubs and dishes', scattered about a cottage door. It is incontestable, none the less, that these surroundings, and especially the river, haunted Turner all his life. London was still the 'Great Smoke', and his childhood acquaintance with rigged ships seen through the mist and fog is one key to the constant exploration of vaporous effects in his art. Little further off upstream were the Houses of Parliament, and the excitement which their destruction by fire set up in him in 1834 is largely explained by his life-long memory of their presence by the river.

The few streets between Covent Garden and the river formed one of those small village communities which still kept their identity in the heart of London. Certainly these streets contained an amount of tradition connected with art, and enough of its living embodiment to fire the imagination of a boy with such a gift as Turner's. It may only be coincidence, but many of the academies of drawing which furthered the education of eighteenth-century artists were founded within a few yards of his birthplace. For instance, there was the St Martin's Lane Academy, reconstituted by Hogarth, and Shipley's drawing-school, part of the Society of Arts. Just before it was taken over by his father, Turner's birthplace had been run for three or four years as an Academy of Drawing by the Incorporated Society of Artists; George Romney, Ozias Humphry, and Francis Wheatley were among the students. The seventeenth century had witnessed the growth of a large colony of artists in the neighbouring streets – amongst them Lely, Hoskins, Cooper, Kneller, Lankrink, and Closterman; and the tavern, the Constitutional, frequented by Richard Wilson, was close at hand. The architect who was one of Turner's first patrons, Thomas Hardwick, rebuilt the church of St Paul's Covent Garden, after the fire of 1795. Turner's contemporary and for

a time rival, Girtin, was the pupil of John Raphael Smith in King Street, Covent Garden, in about 1788, and the first meeting between them is said to have taken place there.

Barber shops still have a certain tradition of providing newspapers and hanging prints on their walls. In the eighteenth century they had a position somewhat analogous to taverns, coffee-houses, and clubs as places of resort, and the idea of hanging young Turner's drawings to be viewed at their leisure by the shop's clientele was in keeping with this function. In the streets around were shops which continued, in their variety, the fame of the earlier days when Covent Garden was the most fashionable neighbourhood in London for shopping. All these visual and historical interests were valuable to Turner. As he was receptive to them, they were an asset turned to advantage in his art.

What was less advantageous, particularly for a landscape painter, was the absence of natural beauty. In spite of Ruskin's praise of his botanical accuracy, Turner did not really look at most natural objects with the attention of one who had grown up with them. He could if he wished focus his remarkable *Ills. 10,* power of vision on trees and plants, but was often content to *75* furnish his paintings with a foliage suggested by Claude. In the vast range of his sketches there are remarkably few studies of such individual objects as weeds or flowers. He does not give the impression that, like Constable, he was filled with enthusiasm at the sight of a fine tree. The natural phenomenon which impressed him most as a boy and which he painted all his life was that characteristically urban one, the play of light through *Ill. 52* smoke, fog, or mist. *The Sun rising through vapour*, the title of a painting he exhibited in 1807, could be the name of half his work.

But he did receive a comparatively early experience of the country. At the age of ten he went to stay at Brentford with his maternal uncle J. M. W. Marshall, who was a butcher living in the market-place. While there he attended the Free School, and laid the foundations of an interest in literature which he

cherished throughout his life. Although he had difficulty in making himself intelligible, he was devoted to reading, especially the poets who, in the 1780s and 1790s, were most clearly protagonists of the Romantic idea – Thomson, Akenside, Campbell. (His affection for Thomson was enhanced by the poet's near-by residence at Richmond.) These beginnings of a literary culture spread to a keen study of the Bible, Homer in Pope's translation and Virgil in Dryden's translation. Later on he absorbed the technical literature about painting and perspective, as well as reading of a more general kind. In Brentford, also, as he himself told his friend the Rev. H. S. Trimmer, he first started drawing, representing cocks and hens on the wall with chalk. This has a reminiscent ring of Bewick's childhood beginnings about it, but may be true. At this time Brentford was a busy market town 'ten miles from London', and the view it gave of the river was rural enough, compared with the Adelphi and the Savoy. It must have been this early transplantation into the country that set up in Turner's mind his lasting affection for the more westerly reaches of the Thames. When he could build himself a country house he did so at Twickenham; in his old age he hid out in his cottage on the river at Chelsea, and died watching the lights in the water he had loved so long. Even with his pedantically exacting requirements the Rev. William Gilpin, the apostle of the picturesque, had found of this environment that 'the river too is here a noble bay, and when we draw near the right hand shore, and can get such a foreground as we had at Thistleworth, we may have a good view. Such a one we had towards Brentford, when we attained a foreground from some of the lofty trees of Richmond Gardens.'

With a gift of such precocity as Turner's there has naturally been much curiosity on how it was nurtured and developed. In the absence of most contemporary records a good deal of later speculation has been brought to bear on the question, 'Who were his teachers?' Thomas Hardwick, the architect, Palice, a flower-painter, John Raphael Smith, Thomas Malton,

Paul Sandby's drawing-school, and Sir Joshua Reynolds' studio are among the names and places for which this is claimed. The theory that he worked in Reynolds' studio seems to stem only from a statement of Turner's that he had copied paintings by Reynolds when a student. That he worked with Thomas Malton is certain, both from an entry made by Joseph Farington in his diary, and also on stylistic grounds. Above all his entrance as a student at the Royal Academy is fully recorded in the minutes for 11 December 1789. The drawing which procured Turner this place for free tuition at the age of fourteen was a study made from a cast. In the following years he continued this academic discipline, both drawing from plaster casts and from life. But he did not neglect his main interest, and in 1793 was awarded a prize for landscape drawing by the Society of Arts.

Ill. 2

He had already started on that course of travelling and sketching from nature which was to form the predominant pattern of his life. The first expedition of this sort made by him was apparently undertaken at the age of fourteen, in the year 1789 which ended with his admission to the schools of the Royal Academy. The occasion was a visit to the uncle who had formerly accommodated Turner at Brentford. He now lived at Sunningwell, a short distance from Abingdon and slightly further from Oxford. While there Turner used a home-made sketchbook, and the subjects he chose were mostly buildings in the neighbourhood. One subject is a distant view of Oxford from the Abingdon Road, the foretaste of a scene to which he returned again and again. From this he made a finished water-colour; the book was already the source for elaborations of this kind and, like virtually all its successors, it remained in the artist's keeping till his death.

Turner was successful in having a drawing chosen for exhibition at the Royal Academy in 1790. This work nicely linked his connections with the two architects who stand as mentors at the beginning of his career. Its title was *The Archbishop's Palace, Lambeth*, and it was the second rendering of a subject

2 *Life study (stabbing scene)* 1790–2. Turner attended Life Classes at the Royal Academy regularly during 1792, then intermittently until 1799

he had first attempted the year before. The first version was made for Thomas Hardwick, who had already commissioned a drawing based on the Oxford sketchbook and another design. The second, exhibited version is close to the style of Thomas Malton, and seems to establish that this teacher's influence was at its height in 1790.

The next year he made a tour of the West Country, including a visit to his father's friend, John Narraway, who lived in Bristol. This journey led to the formation of his second known sketchbook. He was now sixteen, and the selection of subjects shows that wilder and more dramatically romantic scenery was beginning to stir him deeply: the gorge of the Avon, the Hot

Wells, and a ruined chapel on an island in the Severn. He continued with greater address his studies of buildings, par-

Ill. 3 ticularly the Gothic fabrics of Malmesbury and Bath abbeys. These subjects stand near the beginning of a whole series of picturesque treatments of Gothic buildings. In choosing them he was true to the taste of his time, which found the medieval and the ruinous equally causes of picturesque delight and the romantic thrill. At the same time he was in part turning away from the severely logical and precise draughtsmanship he could learn from Thomas Malton, a master who was pleased above all to give a clear and vivid rendering of recently erected buildings and modern street scenes.

These divergent interests were represented by the two draw-ings Turner exhibited at the Academy in 1792. *Malmesbury Abbey*, an elaboration of sketches made by him the year before, was a development of the Gothic theme. *The Pantheon, the*

Ill. 4 *morning after the fire* is a view, in an idiom closely related to Malton, of a ruined building of which Turner had seen the destruction. Whilst in later years the fire itself would have been the subject of the picture, he has given here a static rendering, fully eighteenth-century in logic and colour. There is a sense of drama, in the frozen ice and the crowds, but the façade of the building is given with a completeness which counteracts the sense of disaster. It seems to be the last ambitious drawing in which he worked in so thoroughly Georgian an idiom. The emphasis he had placed on the architectural interest is again brought out by the fact that he made a second drawing of the interior, for his now established collector Thomas Hardwick.

It was probably in the autumn of the same year, 1792, that he began to expand his knowledge of the established centres of picturesque scenery by a visit to Wales. Although confined to

Ill. 7 South Wales, this gave him his first view of Tintern Abbey, the subject of a number of drawings by him in the decade, and

Ill. 5 the river falls and gorges of the Upper Wye Valley. Tintern was a subject already singled out and illustrated by William Gilpin in his *Wye Tour*, a standard guide-book containing

3 *Bath Abbey from the north-east,* from sketches in the Bristol and Malmesbury sketchbook, 1791

4 *The Pantheon, the morning after the fire* 1792. Close in style to Turner's master, Malton

17

5 *Melincourt Fall, Vale of Neath,* from a sketchbook used in South Wales in 1795

6 *Tom Tower, Christchurch, Oxford c.* 1793

18

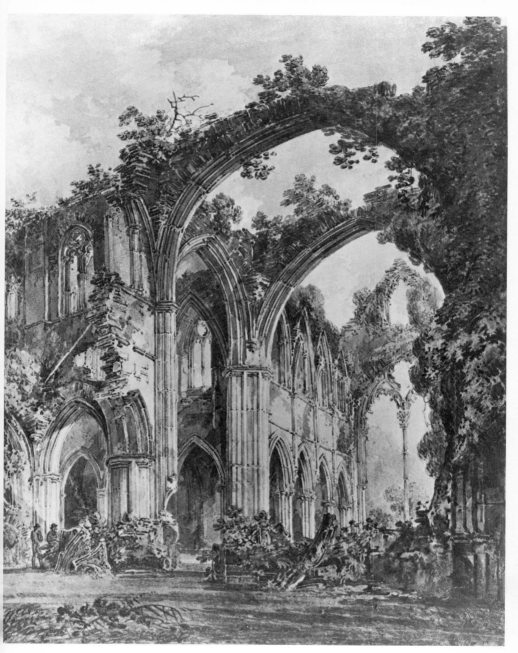

7 *Interior of Tintern Abbey*. Exhibited at the Royal Academy in 1794

picturesque reflections, published in 1783. Of Tintern he says: 'The woods, and glades intermixed, the winding of the river, the variety of the ground; the splendid ruin, contrasted with the objects of nature; and the elegant line formed by the summits of the hills which include the whole; make all together a very inchanting piece of scenery.'

For the remaining years of the century Turner pursued the course on which he had already started so precociously. His exhibits at the Royal Academy increased in number. There were five watercolours in 1794, eight in 1795, ten in 1796. The subjects were culled from his increasing store of sketches made from the rapidly expanding programme of tours. For pure landscape he preferred river scenes in Wales; the neighbourhood of the Devil's Bridge in Cardiganshire occurs on more than one occasion. But more frequently the subjects he sent to the Exhibition were scenes of Gothic architecture with a theatrical sense of Romantic effect. In his *Westminster Abbey:*

8 *Storm off Dover c.* 1793. This unfinished sketch shows the pier in the foreground, a flag at half-mast and a vessel with lowered sails

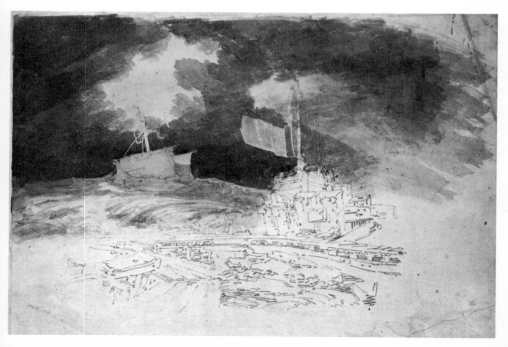

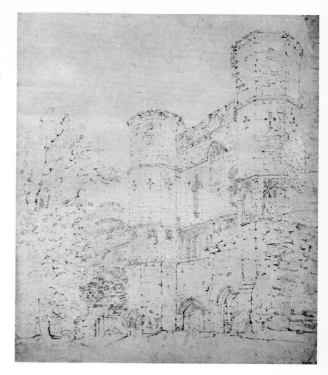

9 *The entrance, Battle Abbey,*
Sussex c. 1794

10 *The old oak,*
from a sketchbook used in
Lancashire and North
Wales *c.* 1799

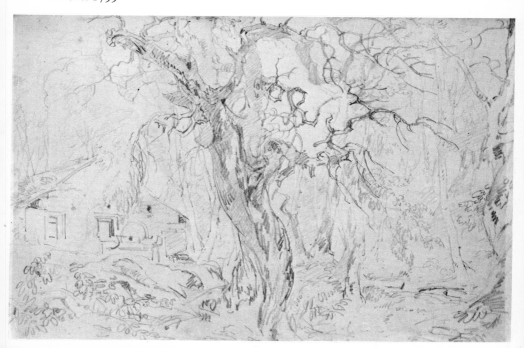

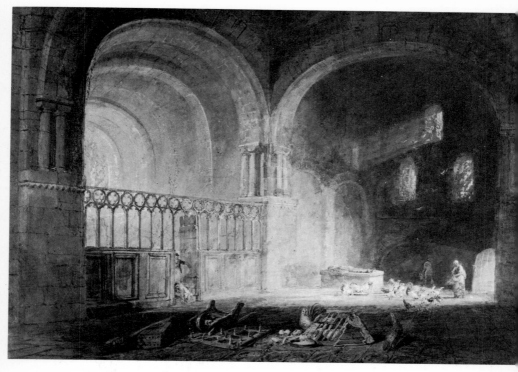

11 *Transept of Ewenny Priory, Glamorganshire.* Exhibited at the Royal Academy in 1797

Bishop Islip's Chapel, exhibited in 1796, the line of sight is placed low and the columns soar outside the top edge of the picture so that the solitary figure and by sympathy the onlooker are dwarfed by the scale of the interior. At the same time he is getting progressively more interested in effects of light, until in *Ewenny Priory,* shown in 1797 and now in Cardiff, the counterpoint of tones in the mysterious shades of the background, pierced by shafts of light, anticipates some aspects of his later explorations of interiors. He is now combining the polarities present in his earlier work, the opposition of reason and feeling, or topography and the picturesque, and has made of it a manner recognized by contemporary critics as entirely his own, with an advance on previous work in the medium of watercolour.

Ill. 11

22

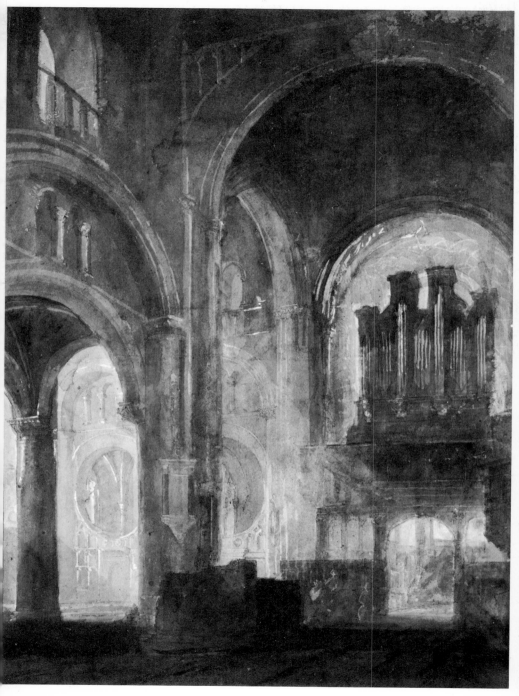

12 *Interior of Christchurch Cathedral, Oxford: screen and organ c.* 1799–1801

13 *Life study*, from Turner's 'Academical' sketchbook, 1798. Ruskin's comment was 'Academy studies, base'

In the last decade of the eighteenth century the topographical landscape was merging into the romantic comment on a wild, picturesque, ruinous or historical scene. The process was coming about through the work of J.R. Cozens, Edward Dayes and amateurs such as William Gilpin and James Moore. In a manner he was to repeat throughout his life, Turner saw the latent possibilities and brought them nearer fruition than his contemporaries. The colours in which he composed the water-colours of this decade were the low-toned blues and blue-greys which had their own emotional melancholic connotation. When nearly fifty years later, he read Goethe's *Zur Farbenlehre* he would see that he had progressed from the negative, gloomy

colours to the positive vital colours typified by the glowing yellows and reds of his later work.

Recognition by critics was not the only, nor professionally the most important, success. The patrons who commissioned watercolours from him, originally Hardwick and one or two early friends, rapidly expanded to include many of the most important clients a young painter could hope to reach. Lord Malden and Sir Richard Colt Hoare in 1795, Edward Lascelles in 1797, the Bishop of Ely; the list of their orders grew until he told Farington in 1798 that he had 'more commissions than he could execute', and more exactly in 1799 that he had 'sixty drawings now bespoke by different persons'. Less resoundingly, but with important results, he was commissioned for drawings for engraving as early as 1794, when he was nineteen years old.

This development was of great interest, in view of the skill with which in later years Turner organized and promoted the sale of prints from his paintings and drawings. For the time it

14 *Two turkeys*, from a sketchbook used in South Wales *c.* 1798. This contains a number of transcripts, or drafts, of songs

was important in bringing his style to public notice and making his name better known. The first of these commissions were for town views, of Rochester, Chester, Ely and so forth, for publication in the *Copper-Plate Magazine*, and the smaller *Pocket Magazine*. The following year, 1795, brought a commission for ten views of the Isle of Wight from John Landseer, the engraver, now better remembered as the father of Sir Edwin Landseer. The association formed in this way lasted many years. Like many another engraver, Landseer had a keen and perceptive eye; he was also not afraid of modernity and the more advanced art of his time. It was thus that he came to write some of the most intelligent and sensitive criticism of Turner's second manner at a time when many former admirers were beginning to lose sympathy with his experiments.

Both the exhibited pieces and the works commissioned by collectors and engravers were worked up from sketches made on his tours. From the outset of his career Turner demonstrated his stamina in travelling and his immense diligence in drawing

15 *Fallen trees by a river bank c.* 1798. From the same sketchbook as *Ill. 14*

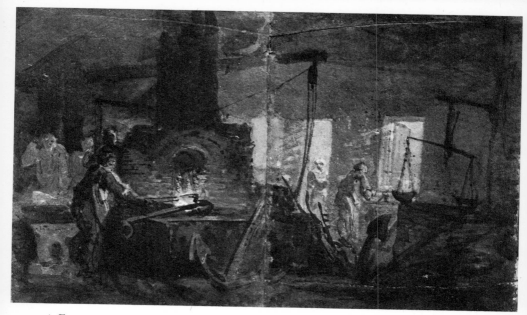

16 *Forge scene*, a double spread from a sketchbook of *c.* 1797, showing men forging anchors

as many motifs as he could; his industry is as remarkable as his ability. His appetite for experience and his energy is shown by his practice of getting up in time to see the sun rise. Only 1796 was an off year, in which he seems to have stayed in Brighton and made very few drawings. The rest of the time was fully occupied: Oxford and Kent in 1793, the Peak District and the Midlands in 1794, the Isle of Wight and South Wales in 1795, the Lake District and Scotland in 1797, North Wales in 1798 and again in 1799. He had not yet evolved the graphic shorthand which enabled him to simplify what he saw into a few swift mnemonic strokes. The 'Isle of Wight' sketchbook of 1795 is a characteristic example of his work in this phase. On his carefully planned itinerary he stopped at Winchester, which provided in *The Butter Cross* the subject of a commissioned watercolour, later engraved. Netley and Southampton were the gateway to the island, where he was most excited not by buildings and views but by the striated cliffs of Alum Bay. Of this subject he

Ills. 6, 8

27

made a remarkably complete and satisfactory watercolour, abandoning for the occasion his more usual practice of sketching with the pencil alone, or with only light washes. Either on his return or on an excursion from Winchester he made a stop at

Ill. 17 Salisbury. Here he sought and drew a series of subjects, the Cathedral and the city, to fulfil a large commission from Sir Richard Colt Hoare. The studies of Gothic architecture are delicate and finely pencilled, but amount in themselves to diagrams, with no search for aerial perspective. From them, however, he made some of his largest and most dramatic watercolours, in which he carried the romantic idiom further than ever before, and used to the full the effect of the edges in cutting off the fabric, making it loom with enormous size.

It may seem strange that an artist of such obvious and recognized accomplishment should, at the time he made these drawings, still have been going to school. Yet it is a fact, established by his own words at the time, that Turner was in 1795 working as a member of the loosely knit assembly of young artists known as the 'Monro Academy' or 'Monro School'. Recent investigation has removed some of the glamour from Dr Monro, the distinguished alienist who gave his name to the academy. He is no longer certainly regarded as a pure philanthropist to the young; in fact it is suggested that he drove a rather hard bargain with them, a view which Turner's father took. His motive, it has been suggested, was merely to obtain for his own collection copies of drawings of which he could not buy the originals, rather than a disinterested desire to see that the artists had the best possible models to copy. Even his choice of copyists, including as it did Turner and Girtin, has been found not to be based upon an uncanny prescience for quality, since his own favourite artists were Hearne and Laporte.

Yet Turner did endure this association for three years and profited from it. It is not clear whether he first went to the Doctor's evenings in 1794 or 1795. It was not before 1794, for that was when Dr Monro moved into the Adelphi Terrace and was first able to entertain his protégés. This house was only two

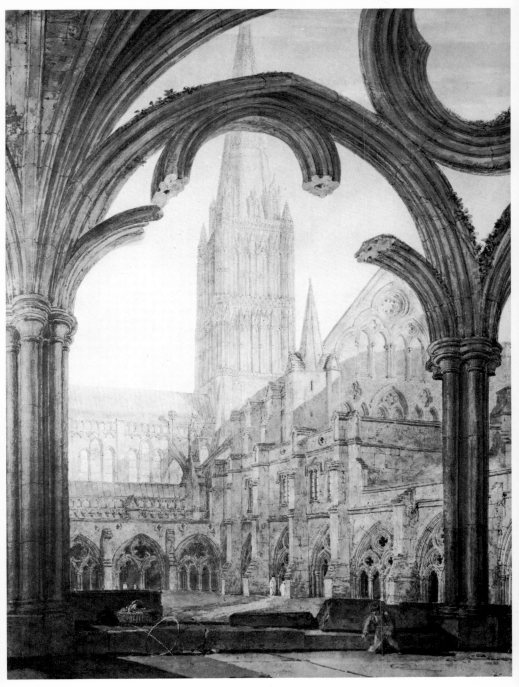

17 *Salisbury Cathedral; view from the cloister c.* 1802. One of the last of a
series of eight watercolours painted for Sir Richard Colt Hoare between
1797 and *c.* 1802

or three minutes' walk from Turner's, with a fine view of the Thames. The arrangement was that the guests should work for three or four hours and receive a fee of 2s 6d or 3s 6d and their supper. The nature of their employment consisted in tracing or copying outline drawings and working them up into a finished effect. The originals which are known to have been used include work by Dayes, Hearne and the amateur John Henderson, who lived next door to Dr Monro. Far more interesting than these, the chief source of the value of the occupation to Turner, as it was to Girtin, was the use of the sketches of John Robert Cozens, the forerunner of English Romantic landscape. Cozens had gone mad in 1794 and was under the Doctor's professional care at Bethlehem Hospital

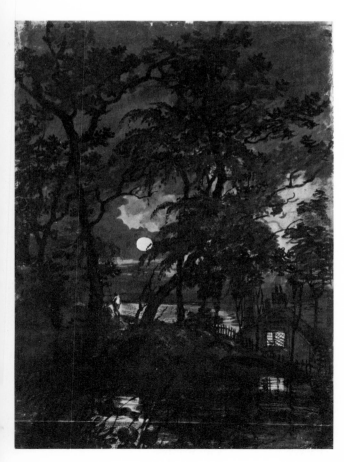

18 *Moonlight between trees c. 1796*

19 *Stormy sky*, from a sketchbook labelled '24 Studies' *c.* 1801. An early example of a sky study and of elliptical notation and rhythmical line

(where Turner's mother was later to go). According to Farington, who made contemporary notes in his diary, Girtin made copies of the outlines of Cozens' sketches, and these were then passed to Turner to wash in and thus finish. The resulting drawings were reinterpretations of Cozens, but in a less melancholy key. They were bold, fresh, decisive. Turner learned not only from them but from the stimulus of working in rivalry with his most gifted contemporary. Girtin, who had been Dayes' pupil and studied at the fount of the new topographical trends, was able to import much, and for a time the style of the two men became similar. More than this, the subject-matter was the wildest and most romantic scenes in Switzerland and Italy. As much as the paintings of Claude and Poussin, these must have fired Turner with the ambition of seeing and painting such scenery.

On Monro's death his collection was put up for sale. A great number of the copies made at these evening sessions were catalogued, apparently rather recklessly, as the work of Turner; these he bought up. Some accounts suggest that Turner was perhaps unworthily jealous of Girtin, who was his own age.

31

There is little evidence for this. At the time they worked to-
gether in the Monro Academy, whether it was in 1794 or 1795,
Turner was far better known. Writing in 1797 a critic remarked
that Girtin's manner was based on Turner's, and at the time
this was a fair view. In the last few years of his life Girtin's style
in watercolour developed away from, and in advance of,
Turner's use of that medium, in warmer harmonies of tone, a
greater breadth of handling, and a choice of viewpoint which
fully brought out the romantic feeling in his landscapes.

But Turner did not need to be apprehensive about this. Not
only was he by then an Associate of the Royal Academy (a
position Girtin never attained), he had started to paint in oils
and was in the process of adopting it as his dominant medium.

Girtin's own career, cut short though it was by his early
death, emphasizes the importance of this step. So far as is known

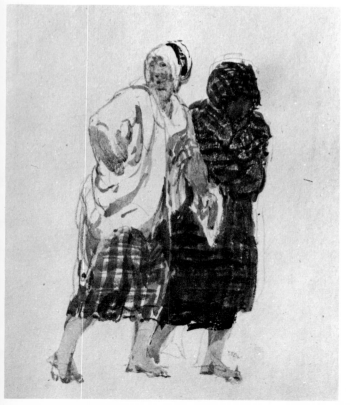

20 *Two women
walking*, page from a
sketchbook used in
Scotland, probably
c. 1801. Turner has used
his thumbprint in the
texture of the skirt
worn by the figure on
the left

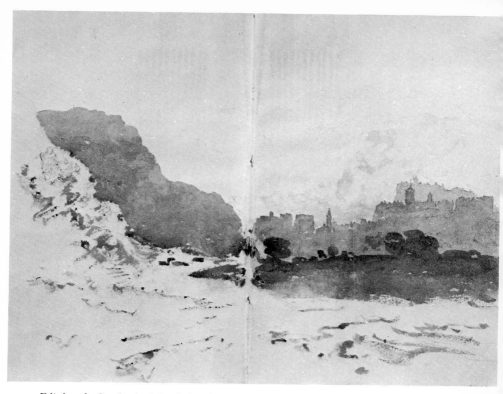

21 *Edinburgh Castle, and St Giles' from near Holyrood,* from a sketchbook of c. 1801

he painted only one picture in oil. In this he was following the tradition of the eighteenth century whereby many British artists did specialize in watercolour to the almost complete exclusion of oil. Paul Sandby, Thomas Hearne, Michael Angelo Rooker, John Robert Cozens (though he painted one influential oil, *Hannibal Crossing the Alps*) were all cases in point. With his startling early success Turner might well have been inclined to follow the natural pressures of patronage and be exclusively an artist in watercolour.

By an admirable piece of artistic detection Mr Finberg, the author of the standard *Life of J. M. W. Turner*, has identified the first oil painting he exhibited. This appeared at the Royal

Academy in 1796 with the title *Fishermen at sea*. More recently known, through its ownership, as *The Cholmeley Sea Piece*, it has been for many years lent to the Tate Gallery by Mr Fairfax-Cholmeley. Singled out for exceptional praise at the time of its exhibition, this work fully justifies a contemporary critic's comment about the proof it gives of 'an original mind'. The engraver E. Bell, who accompanied Turner in one or two of his tours at this time, testifies that this, 'a view of flustered and scurrying fishing-boats in a gale of wind off the Needles', was his 'first oil picture of any size or consequence'. It is certainly a remarkable accomplishment, a moonlit scene showing no sign of faltering in the handling of a new and unfamiliar medium. It combines Turner's own immediate response to the open sea, its life, its movement, its dangers off the coast of the Isle of Wight, with his knowledge of the long line of British marine painters before him, including Scott, Brooking, and Serres.

Turner has frequently been reproached with basing his practice in oils on his watercolour technique. This was, as we shall see, one of the charges which Sir George Beaumont brought against him, and even Constable echoed it. But what *The Cholmeley Sea Piece* shows is Turner learning a completely different range of expression through the new medium. This is in no sense a transcript in oil of the ideas he expressed even in such advanced watercolours as *Alum Bay* and *Westminster Abbey*. Not only does it give him a greater range of light and shade, it enables him to attend to such remarkably subtle distinctions as the difference between the reflection of the mariner's lamp and that of the cloudy moonlight on the disturbed water. It is as much from preference as from the example of his predecessors that he paints the moon circled with a thin veil of cloud; this gives scope for the observation of nuances of colour and tone in which he is already absorbed. For all their dramatic realism and romantic feeling, Wright of Derby and De Loutherbourg, who painted the moon unclouded and did not explore the nuances of light seen through a semi-transparent medium,

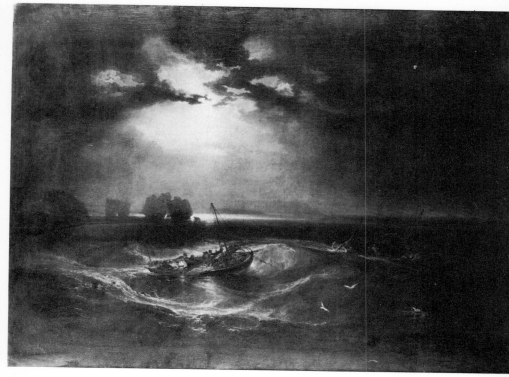

22 *Fishermen at sea (The Cholmeley Sea Piece)*, Turner's first exhibited oil (1796)

do not enter into the examination of these problems. It is also significant, in view of his later work, that the moon is frontal in this picture. Time and again we shall find Turner looking into the sun or moon as the source of light; here is the habit of mind already established in the first work in which he could do it justice.

The decision to embark on oil painting was an important one. While there were hierarchies amongst the different branches of painting, oil was regarded as superior to watercolour, just as history painting was superior to landscape painting. And, though there may have been no positive rule against the election of specialists in watercolour to membership of the Academy,

it is certain that they were discriminated against. The desire to overcome this barrier seems to have been the motive behind Girtin's solitary experiment in oil painting. But while he did not feel drawn to the new medium, it is clear that Turner was, and his ambition was firmly established to become an Associate of the Royal Academy at the first possible moment. When, two years after showing *The Cholmeley Sea Piece*, Turner exhibited his *Buttermere Lake with part of Cromackwater, Cumberland, a shower* he had already advanced greatly in his mastery of the medium; it was becoming possible for him to see and render entirely new nuances of tone and aerial perspective. It is astonishing that Hoppner, who had admired the earlier oil, on seeing this in his studio called Turner 'a timid man afraid to venture', since the note of originality is even more impressively present.

Ill. 23

For the Exhibition of 1798 Turner first followed an accepted practice and added quotations to the entries of his paintings in the catalogue. Four of these he took from Thomson's *The Seasons*. The *Lyrical Ballads* of Wordsworth and Coleridge were published this year, but the Lake Poets did not ever replace Thomson in the landscape painter's repertoire of literary imagery. The fifth quotation is from Milton and begins with words which supply the chief motif of Turner's mature work:

> *Ye mists and exhalations that now rise*
> *From hill or streaming lake.*

All the quotations refer to such effects of light and atmosphere. Indeed the whole choice of texts is interesting in showing Turner's genuine poetic taste and anxiety to find parallels between literature and his own paintings, an anxiety which subsequently led to the composition of his manuscript poem *Fallacies of Hope*. For the painting *Dunstanburgh Castle*, now at Melbourne, he chose a passage from *The Seasons* which thirty years later Constable chose to accompany *Hadleigh Castle*. And he accompanied the watercolour of *Norham Castle* with lines so abstract that they seem more adapted to the better-known

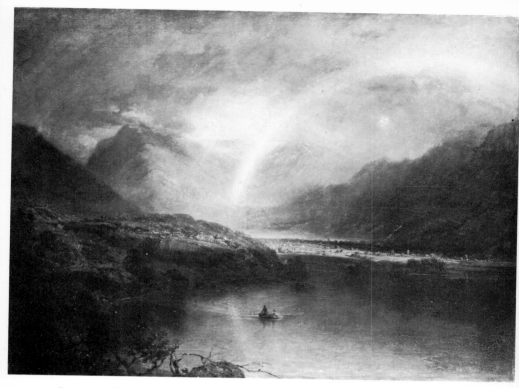

23 *Buttermere Lake with part of Cromackwater, Cumberland, a shower* 1798

later version, an example of his manner at its most non-representational: *Ill. 122*

> . . . *the lessening cloud*
> *The kindling azure, and the mountains brow*
> *Illumin'd.*

After exhibiting in this ample way in 1798, Turner went on a tour of North Wales, seeing the Wilson country for the first time, including Snowdon and the Llanberis Pass. Once again he made a special point of studying castles in their romantic, militarily inaccessible positions; among them were Harlech, Caernarvon, and Dolbadern. On his return he waited for the *Ills. 24, 25* results of his first application to become an Associate of the

Royal Academy. He was already sufficiently in the public eye to have the vote of Joseph Farington, the *éminence grise* of the Academy, and this influential man judged that he had a good chance of being elected to one of the two vacancies. But as it turned out, while Martin Shee, the future President, was elected to the first vacancy, Turner was beaten by Charles Rossi, the sculptor, on the final ballot for the second. But he was well supported and was in any case a year under the minimum age, twenty-four, at which he could be properly elected.

No doubt to force home the impression he had already made with the Academicians, he exhibited another large group of works at the Exhibition of 1799, four oils and seven water-colours. The poets quoted include Thomson's collaborator, Mallet, and the extracts he chose are redolent of evening light and the cheating optimism of youth. Three castles from the North Wales tour of the previous year supplied subjects, and he exhibited two of the impressive watercolours of Salisbury Cathedral commissioned by Sir Richard Colt Hoare. Two other watercolours, *Abergavenny Bridge* and *Warkworth Castle* are now in the Victoria and Albert Museum, London. Though spacious in construction, they are conceived in a rather drab

24 *Study for Dolbadern Castle*,
page from a sketchbook
of *c.* 1800
containing studies for paintings

38

25 *Dolbadern Castle* 1800.
Turner's Diploma work,
exhibited at the Royal
Academy in 1800

palette varying from deep blue to ochre. Turner has been trying
to import some of the richness he has learned from his oil
painting into this medium, and has at the same time attempted
to assimilate some of the results of Girtin's remarkable progress
towards warmth of tone and breadth of effect, but the result in
his case is a certain heaviness. The year 1799 was notable for
the formation of a Sketching Society, of which Girtin was a
leading member, 'for the purpose of establishing by practice a
school of Historic Landscape, the subjects being designs from
poetick passages'. Turner was not a member but showed his
awareness of what was in the air by making one of these
exhibits at the Academy an illustration to Dr Langhorne's
Visions of Fancy. The watercolour is no longer known, but the

extract he chose gives a foretaste of the pessimism he later expressed at length in his own poetry. It contrasts 'life's morning landscape', full of hope and joy, with the threat of a 'dark cloud gathering o'er the sky'. This may be the first occasion on which Turner deliberately escaped from the portraiture, however romanticized, of places to paint a specifically poetic and non-localized theme. The oil painting in the Turner Bequest,

Ill. 26 *Aeneas and the Sibyl, Lake Avernus*, though unexhibited and undated, may stem from the same time. It is heavily imbued with the spirit of Wilson, who had made the most significant contribution to British historical landscape so far in his *Destruction of Niobe's Children*. The choice of subject shows that Turner has already become familiar with Virgil's narrative. The story of Dido and this sequel to it especially haunted his imagination; and he returned to the theme in *The Bay of Baiae, with Apollo*

Ills. 101, 144, 176 *and the Sibyl* of 1823 and *The golden bough* of 1834, and the last subjects he ever exhibited were of scenes from the *Aeneid*. It became his ambition to make a vital contribution to the genre of historical landscape, which had been denigrated by Reynolds, and he planned to encourage it in his lectures on perspective and when making the first drafts of his will.

The recent discovery that in all probability Turner designed the panorama of the *Battle of the Nile*, exhibited at the Naumachia in 1799, illuminates the intentions and direction of his art as he became fully conscious of his strength. Such scenes were a rudimentary forerunner of the colour cinema; in this example the vessels in the battle were seen in motion, the exchange of fire was rendered, and the performance ended with a grand finale of the blowing up of the French ship *L'Orient*. It was an art form which derived partly from painting, partly from the stage, and had been inaugurated by De Loutherbourg with the *Eidophusikon* which he had introduced in 1781. De Loutherbourg had brought in a new era of spectacular scenic effects on the stage and carried these ideas on to this form of entertainment. He imitated the atmospheric effects of different times of day, and amongst the subjects he dealt with were

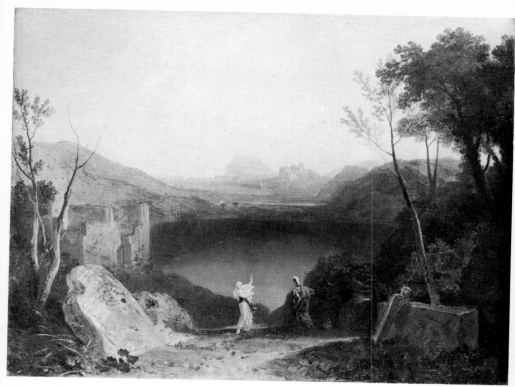

26 *Aeneas and the Sibyl, Lake Avernus* c. 1800.

the dawn seen from Greenwich Park, a storm over London, a sunset in an Italian port, a moonlight scene in the Mediterranean, a shipwreck, Niagara Falls and Satan arraying his troops, with the building of Pandemonium. This device, which enchanted Gainsborough and Reynolds, also pleased Turner, and we may look not only for one explanation of his repertory of subjects, but also for the enhanced emphasis of his handling in this practical experience of its possibilities. In particular we may find here the first trace of the fires which burn in his *The fifth plague of Egypt*, exhibited the following year. Meanwhile, his second application to the Academy was successful and he became an A R A on the last day of the eighteenth century.

Ill. 28

41

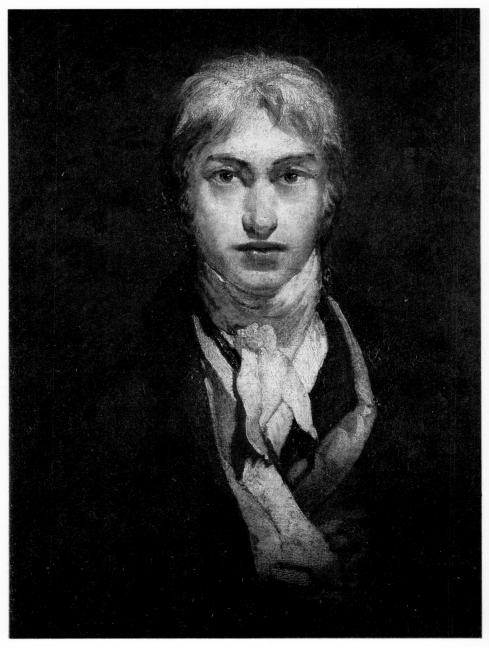

27 *Portrait of the artist aged about twenty-three c.* 1798

The Academician

When he was making his first attempt to become an ARA, Turner had, as we have seen, obtained the influential help of Joseph Farington. When he called on his sponsor to discuss the situation, in October 1798, he talked about his material circumstances, in particular his continuing to live with his parents at the barber shop in Maiden Lane. Farington 'thought he might derive advantages from placing himself in a more respectable position' and advised him to lay aside 'a few hundred pounds'. Undoubtedly, Turner already had substantial savings. In the following year Angerstein paid him forty guineas for a drawing, at the time when he had sixty unexecuted commissions. He could well claim that he was earning more than he spent.

The dissatisfaction with his life at home revealed by this enquiry was enhanced by his election to the Academy, and consequent increase in dignity. But the decisive event which led to his moving was the death, in May 1798, of John Danby, a well-known composer of glees. Turner was either already acquainted with his wife Sarah, a young actress and singer, or became friendly with her shortly after Danby's death. She soon became his mistress and around 1799 Turner was helping to support her and her four children by her husband. His own first child by her, Evelina, appears to have been born soon afterwards. But he did not, so far as is known, live with her, setting up rather, at the beginning of 1800, in lodgings in Harley Street. The arrangement suited him well. He had, as his more licentious sketches show, a normally sensual nature; on the other hand he always successfully evaded any human tie which made too exclusive a demand upon him. Marriage, or

a permanent liaison, would have interfered too much with his concentration on his work, and his frequent absence on long sketching tours. At the same time he was able to indulge in his passion for secrecy about his personal affairs.

The episode would not seem so memorable were it not for the comical attempts of the early biographers to explain it away. Finberg, in his standard work, thought that 'there is no evidence to suggest that Mrs Danby was anything more than a house-keeper'. Other writers, confounding Sarah Danby with her niece Hannah who was a cripple and kept house for Turner in later years, considered her, quite unjustly, an example of his boorish, vulgar taste in people.

In the preceding year or two Turner had found as a patron one of the richest collectors of his time, William Beckford. For him he made five drawings of Fonthill exhibited at the Royal Academy in 1800, duly showing the unfinished tower as completed and breaking up the foreground to supply a correctly picturesque setting for this great mock abbey. But probably Beckford fulfilled for Turner an even greater service when he bought the two 'Altieri' Claudes from Rome and allowed artists and the public to see them in his London house, in the spring of 1799. Turner was there, and his reaction to the *Sacrifice to Apollo*, reported by Farington, was that 'he was both pleased and unhappy while he viewed it, it seemed to be beyond the power of imitation'. That imitation should be his first wish is entirely characteristic. The stimulus of seeing these two works combined with a general enlargement of his world which occurred at this time. His election as A R A, his escape from his father's house, and his liaison with Sarah Danby gave him greater self-confidence and caused the flowering of his ambition. In his art this took the form of his first essays in historical painting. For the first exhibited oil painting in this manner Turner chose a subject from the Bible, which he called *The*
Ill. 28 *fifth plague of Egypt*. In fact, the theme is the seventh plague, as is revealed by the quotation printed in the catalogue: 'The Lord sent thunder and hail and the fire ran along the ground.'

The classical logic of the layout is derived from Poussin, but Turner has heightened any model he may have known from his own experience of natural phenomena. The fiery sky which lights the Egyptian horizon with a livid light is of a wild romanticism which fully reflects the destructive passion in the disaster. It is said that he took these laden clouds from a storm he had witnessed in the Snowdon area; and certainly it has the appearance of a sky observed and not imagined. The care with which he sought accuracy in the historical setting is shown by the existence in his sketchbooks of drawings of the Egyptian Gods Osiris and Apis, and other archaeological details. His knowledge of panoramas and the like has also added to the lurid lighting and dramatic realism.

This painting is a work of remarkable originality, and is the real origin of the apocalyptic themes of John Martin and Danby which matured twenty years later, from which Turner himself took ideas for his last paintings. It was bought by Beckford and the prospect of finding himself in the same collection as the 'Altieri' Claudes must have been a significant impetus towards his final ambition to hang beside his forerunner in the National Gallery.

The success of this work led to a commission for a pastiche of another old master on a larger scale. The Duke of Bridgewater wanted him to paint a companion piece, the same size, to a work in his collection by Willem van de Velde the Younger. It was to measure five by seven feet and Turner worked carefully on variant designs before he found one to satisfy him. It was ready for the 1801 Exhibition, to which he also sent another history piece in oils and four watercolours, and attracted great attention. But to some it seemed almost a plagiarism, and it is at this moment that we hear for the first time of a measure of dissent from the influential amateur Sir George Beaumont, and his young protégé John Constable. So far as Beaumont was concerned, his doubts about Turner were to harden quite soon into deliberate opposition. But his ambition and his existing achievement were not disregarded. Three vacancies amongst

28 *The fifth plague of Egypt* 1800

the forty Academicians occurred in quick succession in 1801. When the election was held early in the following year, Turner was decisively voted into the first vacancy as a full Academician. So, shortly before his twenty-seventh birthday he achieved his greatest professional desire; he remained fiercely loyal to the Academy for the rest of his life.

He had already decided to continue with the grand subjects which had brought him success, and for his major contributions to the Exhibition of 1802 sent two sea-pieces – *Fishermen upon* *Ill. 30* *a lee-shore, in squally weather* (now at Kenwood) and *Ships bearing up for Anchorage*, bought by Lord Egremont and still at Petworth. With these he sent an even larger historical picture, *Ill. 29* this time of *The tenth plague of Egypt*, illustrating the death of the first-born.

46

29 *The tenth plague of Egypt* 1802

30 *Fishermen upon a lee-shore, in squally weather* 1802

31 '*Our landing at Calais. Nearly swampt*' 1802. From a sketchbook of 1802–5 containing studies for pictures including many for *Calais Pier* (*Ill. 54*)

Shortly before the Summer Exhibition opened in 1802 the Treaty of Amiens was signed. By putting a temporary end to the war between England and France this made for greater freedom of movement. Napoleon had looted the more important collections of Europe in his conquest, and placed his captures on show in the Louvre. It was a remarkable, short-lived chance for artists to see works they knew only through copies or engravings, and Turner was among the first to accept it. He left England for Paris on 15 July. In the three months he stayed away he was able to fulfil two distinct ambitions. His first aim was to see with his own eyes the mountains and valleys of Switzerland which he had studied vicariously by copying Cozens' drawings at Dr Monro's house. The second, equally important, aim was to see the collection at the Louvre. Here Napoleon had added to the great masters of the Low Countries and Germany what he himself called 'everything beautiful of the art of Italy'. His chief help in amassing this collection,

48

Denon, said in 1812, 'The Emperor has completed the most astounding collection of art that has ever been formed, which has fallen to him through his victories.' In 1802 it attracted visits from West, Fuseli, Hoppner, Opie, Flaxman, and many others.

Even the most comprehensive international exhibition of this century can hardly have matched this display of masterpieces. To English artists, still without a National Gallery, and dependent upon hardly sought admission to private houses, on foreign travel and on the use of engravings for the knowledge of their predecessors, it gave a unique opportunity.

Turner's arrival was dramatic enough and he sketched the storm-swept harbour at Calais as he landed in drawings which formed the basis of his *Calais Pier, with French poissards preparing for sea: an English packet arriving*, of 1803. The travelling arrangements he managed with his customary energy, prudence and thrift, buying a *cabriolet* in partnership with others and bargaining for everything. His route took in a wide swathe of

Ill. 31
Ill. 54

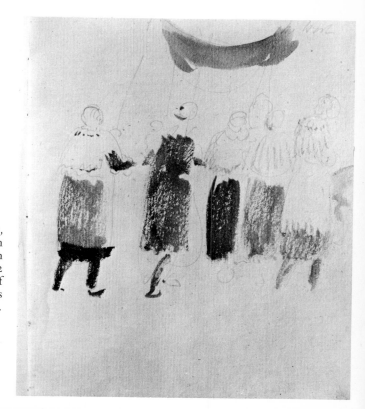

32 *Women in procession, Switzerland* 1802. From a sketchbook used in Switzerland in 1802 containing studies of peasants, a religious procession, etc.

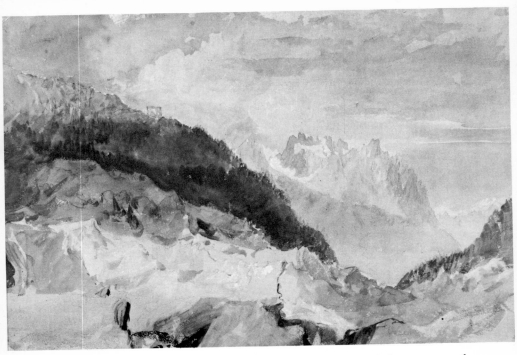

33 *Mer de Glace, Chamonix, with Blair's Hut* 1802. A large watercolour formerly in the Fawkes collection, Farnley Hall, is based on this sketch

Switzerland, including the Grande Chartreuse, the Mer de
Ill. 33
Glace, the tour of Mont Blanc, the Devil's Bridge on the St
Ill. 34
Gothard Pass, and the Falls at Schaffhausen. It was hard travelling and he told Farington that 'he underwent much fatigue from walking, and often experienced bad living and lodging'. His other recorded comments on the trip do not sound rapturous – the trees, except the walnuts, were bad for a painter, the houses were of bad form and had abominable red tiles, the wine was too acid, but the country 'on the whole surpasses Wales, and Scotland too'. For his real response we have to look not at what he told Farington but at his sketches – he made over four hundred drawings in six sketchbooks – and the use of Swiss scenes as subjects throughout his life. It was seventeen years before he returned to the Alps. The immediate apprehension of

34 *The Passage of the St Gothard* 1804

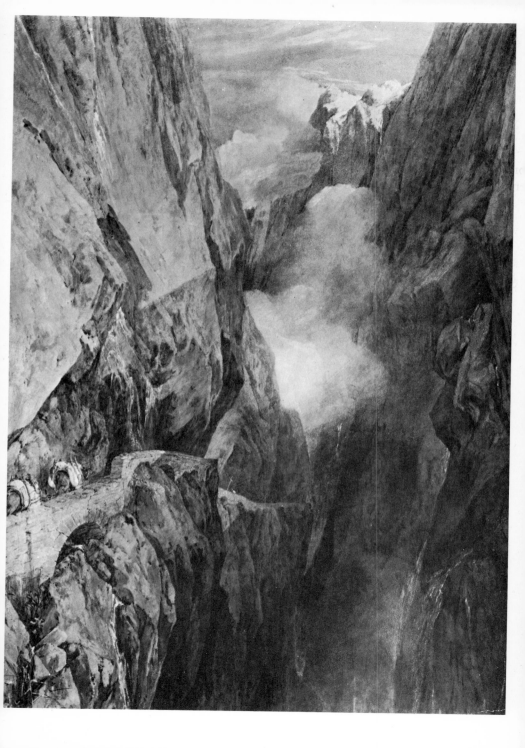

romantic scenery is at its most intense in *The Passage of the St Gothard*; the vertiginous terror of the place is expressed in a tight vertical composition and effective near-monochrome palette. The drawing embodies the principles of Burke's theory of the sublime, and it extracts the ingredients of horror and awe from a natural scene felt in all its grandeur.

Returning to Paris after about ten weeks, Turner immersed himself in studying the paintings in the Louvre. Here he sketched and made analytical notes on over thirty of the paintings which most would serve his desire to enlarge his own art. He paid the greatest attention to Poussin, whom he approached in the manner of a critic who had already seen some of his best work in the collections of the Duke of Bridgewater and Lord Ashburnham. Titian also occupied him a good deal. Among the other Italians he sketched from, or made notes about, were Raphael, Correggio, Guercino and, with particular enthusiasm, Domenichino. He was critical of Rembrandt and Rubens, and his guarded approval of Ruysdael shows that he was not temperamentally in tune with the precise modelling, clear light and sweeping skies of the Dutch landscape painters.

What is most significant, so far as his own practice is concerned, is that his sketches and notes pay great attention to the overall colour harmonies of the paintings. He has become conscious of an analogy between musical modes and the gamut of colour which varies from painting to painting according to its mood. The colour of *The Deluge* by Poussin is sublime because it inexplicably but perfectly conveys the note of horror natural to the event. Of Guercino's *Resurrection of Lazarus* he wrote, 'the sombre tint which reigns thro[ugh]out acts forcibly and impresses the value of this mode of treatment, that may surely be deemed Historical colouring'. It is the nearest he comes to a concise definition of what system of colour was then considered appropriate to history painting.

So far does he carry his concentration upon the balance of colour, and its overall effect, within these paintings, that he has even jotted on a page of his sketchbook two schemes in which

initial letters stand for the colours. They are placed in their spatial relationships, but he gives no hint of the form of the whole painting or its parts. It is the first sign of a use of colour almost abstracted from natural form, seen at its most extreme in some of his last exhibited canvases and even more in the 'Colour Beginnings' and other unexhibited works.

Ills. 128–31

As has already become apparent Turner's immediate reaction in front of a painting by another master was, 'I can do better, or at least as well.' But it shows the strength of his powers of assimilation that when presented with such a visual banquet as the Louvre then offered he did not either despair or become confused in his aim. He had settled down to analyze the twenty or thirty works which at that stage meant most to his development, and to concentrate on those aspects which were to be of more lasting concern: the choice of subjects which could receive epic treatment and the successful use of colour as a form of emotional expression.

Titian's *St Peter Martyr* was a natural object of attention as the most renowned example of the marriage of dramatic action in the figures with a landscape suitable to a theme of martyrdom. It is interesting to compare Turner's analysis with Constable's. Turner wrote in his notebook:

This picture is an instance of his great power as to conception and sublimity of intellect. The characters are finely contrasted, the composition is beyond all system, the landscape tho' natural is heroic, the figures wonderfully expressive of surprise and its concomitant fear. The sanguinary assassin is striding over the prostrate martyr, who with uplifted arms exults in being acknowledged by Heaven. The affrighted Saint has a dignity even in his fear – and tho' Idea might have been borrow'd yet is here his own. The force with which he appears to bound towards you is an effort of the highest powers. The angels, finely introduced, are buoyant. Surely the sublimity of the whole lies in the simplicity of the parts and not in the historical colour.

53

He derives the 'historical colour' from the use of a 'neutralizing tint' passed over the whole painting. Constable said of the same picture, which he only knew from a copy or engraving:

> In the year 1520, Titian, then in his fortieth year, produced his celebrated picture of the martyrdom of the Dominican Peter, the background of which, although not the model, may be considered as the foundation of all the styles of landscape in every school of Europe in the following century. In this admirable union of history and landscape, the scene is on the skirts of a forest, and the time verging towards the close of day, as we may judge from the level and placid movement of the clouds on the deep blue sky, seen under the pendant foliage of trees which overhang the road. The choice of a low horizon greatly aids the grandeur of the composition; and magnificent as the larger objects and masses of the picture are, the minute plants in the foreground are finished with an exquisite but not obtrusive touch, and even a bird's nest with its callow brood may be discovered among the branches of one of the trees. Amid this scene of amenity and

35 *The destruction of Sodom c.* 1804

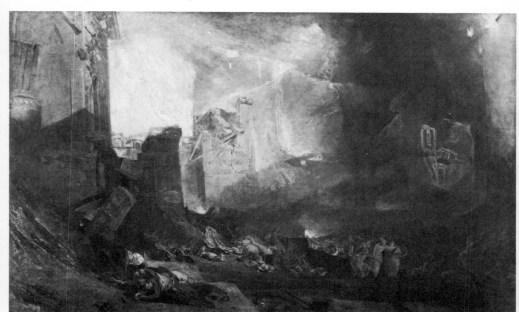

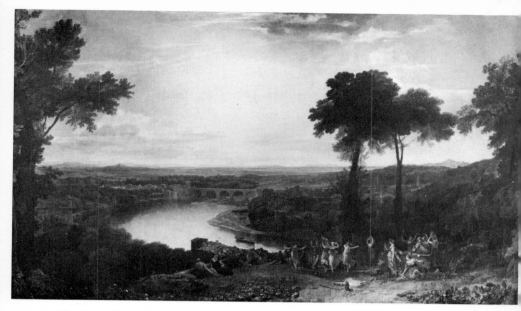

36 *The festival upon the opening of the vintage at Macon* 1803

repose, we are startled by the rush of an assassin on two
helpless travellers, monks, one of whom is struck down, and
the other wounded and flying in the utmost terror. At the
top of the picture, through the loftiest branches of the trees,
a bright and supernatural light strikes down on the dying
man, who sees in the glory a vision of angels bearing the
emblems of martyrdom; and illuminating in its descent the
stems and foliage, contrasts with the shadowy gloom of the
wood. The elder bush, with its pale funereal flowers, intro-
duced over the head of the saint, and the village spire in the
distance, the object of his journey, increase the interest and
add to the richness of the composition. Admirable also is
the contrivance of the tight-drawn drapery, part of the
garment of the martyr, which, pressed by the foot of the
assassin, pins his victim to the earth. The noble conception
of this great work is equalled, I am told, by its breadth and
its tone, while the extreme minuteness and variety of its
details no way impair the unity of its impression.

55

37 *Holy family.* Exhibited at the Royal Academy in 1803

It is typical that Turner should look first at the general effect, while Constable's attention was attracted by the naturalistic detail of the foliage and the distant village spire and, while Constable made only a large-scale drawing of the stricken monk for a lecture illustration, Turner momentarily assimilated the whole composition into his pictorial schemes. A note in his sketchbooks shows that he originally intended to base the composition of his *Holy family* upon it; this, however, he substantially revised before including the religious painting among his exhibits for 1803. The discarded vertical composition, with *amorini*, he used instead for the *Venus and Adonis* (now in the Huntington Hartford Collection), a fine example of his crisp, dry handling of paint in this decade.

Ill. 37

Ill. 38

56

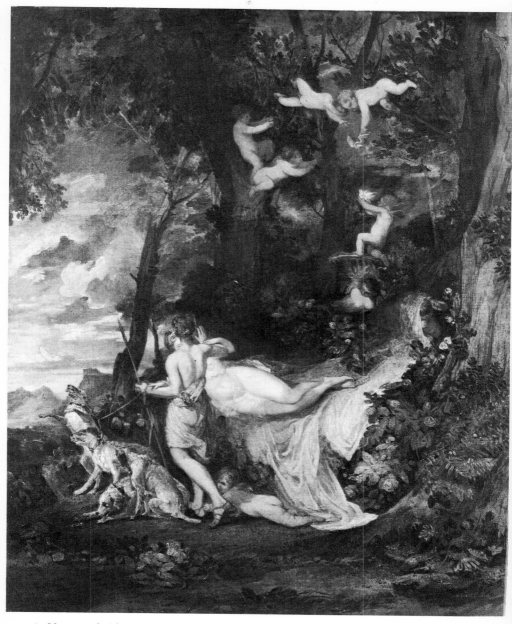

38 *Venus and Adonis c.* 1803–5

From the moment he became a full Academician in 1802, Turner threw himself with energy into its institutional activities. The feeling of acceptance by an established, independent professional society was of especial significance to a man who had grown up in a constricted, unimportant and unhappy home, and to the end of his days the Academy was Turner's *alma mater*. At the moment when he was elected, the institution was riven by one of its periodical feuds, in this case one between the 'Court party' and the 'Democrats', and being young, ambitious and excited by his elevation, Turner threw himself with enthusiasm into these relatively petty quarrels. He clashed on one occasion with Sir Francis Bourgeois, Landscape Painter to the King, whom he despised as an artist, no doubt rightly. It was a question of giving prizes for architecture and sculpture. Bourgeois incautiously said that he decided his vote on the opinions 'of those who were most conversant in those respective studies'. Turner could not resist saying that he ought to do the same for the painting prizes. The exchange degenerated into

39 One of Turner's more intimate studies of the female nude 1809–10. The same sketchbook contains, on another page, the inscription 'Woman is Doubtful Love', as well as miscellaneous notes

40 *Picture gallery*. From a sketchbook begun in 1808 which contains a number of designs for the arrangement of a picture gallery, possibly connected with Turner's building plans for his own house

Bourgeois calling Turner 'a little reptile' and Turner telling Bourgeois that he was 'a great reptile with ill manners'.

On a more awful occasion in the spring of 1804 Turner quarrelled with Farington, who has recorded this exchange, and is our only source for the succeeding row. Farington had left a meeting to confer privately with Bourgeois and Smirke on a matter of business:

> On our return to the Council we found Turner who was not there when we retired. He had taken my Chair and began instantly with a very angry countenance to call us to account for having left the Council, on which moved by his presumption I replied to him sharply and told him of the impropriety of his addressing us in such a manner, to which he answered in such a way, that I added his conduct as to behaviour has been cause of complaint to the whole Academy.

These remarks were sufficiently wounding for Turner to stay away from the Academy for a time.

An effect of the strong financial situation he had now built up for himself was that he was able to extend his house in Harley

Street to provide a large exhibition gallery, seventy by twenty feet. Here in 1804 he started to hold his own one-man shows of paintings. It was a novelty in British painting for an artist thus to undertake such a systematic presentation of his work, though there were precedents for it in France. The change of emphasis, combined with the quarrels within the Academy, altered the pattern of Turner's exhibitions for many years to come. In 1803, in the first flash of enthusiasm at being made an Academician, he showed seven works, five in oil, at the Royal Academy. The next year, when he opened his own gallery his contribution to the Academy dropped to two oils and one watercolour. In 1805, after the dissension with Farington, he sent none at all, and the gallery exhibitions became the chief outlet for the sale of his paintings.

The exhibits, during the next eight or ten years, whether at the RA or Turner's gallery, fell into a number of types. First of all are the oil paintings in which a chief motive is the desire

41 *Shipwreck c.* 1805, a sketch for the painting illustrated on the facing page

42 *The Shipwreck*. Exhibited in Turner's Gallery in 1805

to emulate specific old masters in composition, scale and ability. Of works painted in emulation of Poussin we have already considered *The fifth plague of Egypt* of 1800 and *The tenth plague of Egypt* of 1802; this series he continued with *The deluge*, in which he sought to counteract the weaknesses of incident he had commented on in Poussin's *Deluge*. He appears to have shown this Biblical piece in his own gallery in 1805. Then there are the great machines in which he has sought to outdo Claude, reaching a climax in the *Dido building Carthage; or the rise of the Carthaginian Empire* of 1815, a work he willed to hang beside Claude's *Seaport* in the National Gallery. There are the sea-pieces in which the aim is to outvie Van de Velde. This phase, inaugurated by the Duke of Bridgewater's commission to paint *Dutch boats in a gale: fishermen endeavouring to put their fish on*

Ill. 69

Ills. 54, 42

board in 1801 as a companion to his Van de Velde, was continued in the *Calais Pier* of 1803 and *The Shipwreck* in 1805. Paintings in which the figurative interest predominates were not confined to the religious or allegorical subjects sparked off by the Titians

Ill. 37

in the Louvre – for instance, the *Holy family* of 1803, and the *Venus and Adonis* of 1804. In 1808 he was commissioned by Payne Knight to paint a pendant for his *Candle Piece* by Rembrandt. Although Turner's notes on a Rembrandt in the Louvre read 'miserably drawn and poor in expression', he accepted the challenge and produced a passable pastiche in the work he called *The unpaid bill, or the Dentist reproving his son's prodigality.*

When Wilkie made his first success in London with the exhibition of the *Village Politicians* in 1806, Turner was impelled to show that he, too, could excel in contemporary genre painting. Accordingly, he sent to the Royal Academy in 1807,

Ill. 43

as one of two exhibits, *A country blacksmith disputing upon the*

43 *A country blacksmith disputing upon the price of iron . . . 1807*

44 A sketch inscribed by Turner *Death of Liseus (?)* c. 1805–7

45 *The Goddess of Discord choosing the apple of contention in the garden of the Hesperides* 1806

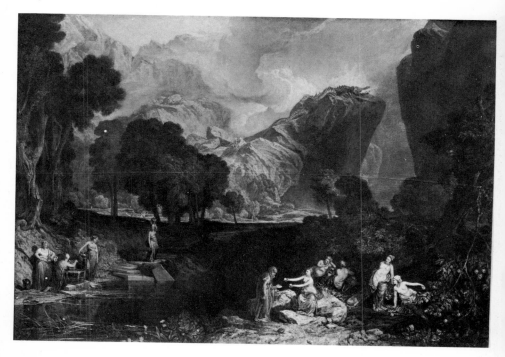

price of iron, and the price charged to the butcher for shoeing his pony.
It was even reported that he had toned-up his painting during
the 'varnishing days', so that it would outshine Wilkie's
contribution, *The Blind Fiddler*. Such a procedure would be
eminently characteristic of Turner; however, Wilkie was able
to hold his own and Turner's interest in humorous genre
was concentrated in the figures of his watercolours.

To these various facets of his imitative ambition Turner
contributed his own personal note. This inheres partly in the
evident fact that he paints what he himself has seen and
thoroughly absorbed into his own uncanny visual memory.

Ills. 54, 28 The sea in *Calais Pier*, the storm in *The fifth plague of Egypt* are
entities he has observed, studied and remembered, and their
actuality gives originality to the whole. Another personal
characteristic, making Turner's paintings works of the nine-
teenth century rather than solely seventeenth-century pastiches,
is the individual and inventive nature of his technique. This
experimental inventiveness may well spring from his early and
thorough training in the more ductile watercolour medium.
After an earlier report that in using watercolour, 'Turner has no
settled process but drives the colours about till he has expressed
the idea in his mind', Farington recorded his practice around
1804 with some particularity:

> The lights are made out by drawing a pencil with water in it
> over the parts intended to be light (a general ground of dark
> colour having been laid where required) and raising the
> colour so damped by the pencil by means of *blotting paper*;
> after which with crumbs of bread the parts are cleared. Such
> colour as may afterwards be necessary may be passed over the
> different parts. A white chalk pencil (Gibraltar rock pencil)
> to sketch the forms that are to be light. A rich draggy
> appearance may be obtained by passing a camel Hair pencil
> nearly dry over them, which only *flirts* the damp on the part
> so touched and by blotting paper the lights are shown
> partially.

Precisely this inventiveness with methods is to be found in his handling of oil paint, and accounts for the difficulty his contemporaries had in understanding it. 'The sea looks like soap and chalk' was a newspaper comment on *Calais Pier* and Opie said in 1804 of his *Boats carrying out anchors and cables to Dutch men of war, in 1665* that the water 'looked like a turnpike road over the sea'. This effect, to his contemporaries, was the result of his combination of work with the palette knife and the restrained low tones of his pigment. He achieved the natural appearance he wanted, and did not care that the methods of its achievement were left visible.

Even so it is tempting to wonder whether Constable had Turner particularly in mind when he wrote his preface to *English Landscape Scenery* in 1830. This, in one draft form at least, is an unashamed piece of personal self-justification:

In Art as in Literature there are two modes by which men aim at distinction; in the one the Artist by careful application to what others have accomplished, imitates their works, or selects and combines their various beauties; in the other he seeks excellence at its primitive source Nature. The one forms a style upon the study of pictures, and provides either imitative, or eclectic art, as it has been termed; the other by a close observation of Nature discovers qualities existing in her which have never been portrayed before, and thus forms a style which is original.

'A wonderful range of mind'

Much of the thematic material for the paintings exhibited up till 1819 came from ideas Turner had formulated by 1802. By that time he had singled out the Old Masters who most stirred his ambitions, and the vigorous sketching tours he had made left him with plenty of motifs. He had switched his main energies from fulfilling commissions for topographical land-scapes in watercolour to the construction of oil paintings on a large scale. For some years after his visit to France and Switzer-land he was less assiduous in travelling. Partly this was due to other preoccupations. Having achieved a financial indepen-dence, he was consolidating his position first by opening his own gallery, then establishing himself in a house up the Thames, at Hammersmith to begin with, then at Twickenham.

In these years of relative immobility, Turner did move away from London and the Thames for the express purpose of visiting friends, undertaking commissions for patrons, or for a special historic event. Thus he went to Portsmouth in the autumn of 1807 to see the Danish ships which had been captured at the Battle of Copenhagen. He was patriotically interested in English naval history in this eventful time: he had sketched the *Victory*, still bearing the body of Nelson, when she entered the Medway in 1805, and set to work on the large painting, *The* *Ill. 46* *Battle of Trafalgar* which he exhibited in an unfinished condition in his own gallery in 1806 and in a more completed state at the British Institution in 1808. A difficult, original work, this gave the battle in progress from the unusual viewpoint of the 'mizen starboard shrouds of the *Victory*'. But when he exhibited his painting of *Spithead* at the Academy two years after he had sketched the captured ships, he made no reference to the

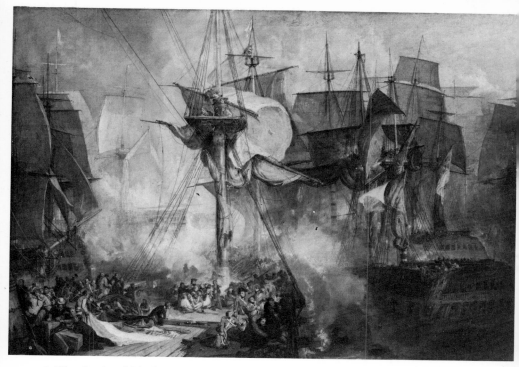

46 *The Battle of Trafalgar as seen from the mizen starboard shrouds of the 'Victory'* 1805–8. Nelson, mortally wounded, on the deck

Danish surrender. It passed as a view of British ships in a British harbour, with the subtitle 'boat's crew recovering an anchor'.

In 1808 he was invited by Sir John Leicester to paint views of his seat, Tabley House, in Cheshire. Sir John Leicester was a leading spirit in the movement to form collections of paintings by contemporary British artists. His relations with Turner had begun with a rebuff entirely characteristic of the painter's stern professionalism in the selling of his pictures. Sir John had admired *The festival upon the opening of the vintage at Macon*, one of Turner's exhibits at the Royal Academy in 1803. Turner was asking 300 guineas for it, a high price at the time. Sir John offered 250 guineas, which was refused. The next year he offered to pay the original price, but by now Turner had raised it to 400 guineas. It was later bought by Lord Yarborough for that sum.

Ill. 36

Ill. 42 In spite of this uneasy start Sir John persevered and did the next year buy from Turner's own gallery his *The Shipwreck*; he also consented to the publication of an engraving after this successful work. The invitation to stay at Tabley to paint two aspects of the house followed soon after. A fellow artist also staying there reported that Turner spent most of his time fishing rather than painting. But a contemporary critic fairly summed up the differentiating quality in his views when he wrote that 'in any other hands [they] would be mere topography', but 'have assumed a highly poetical character. It is on occasions like this that the superiority of this man's mind displays itself'. Leicester continued to buy, and when he opened his gallery to the public in London in 1819 it contained eight of Turner's oils, more than by any other living artist in the collection, thus giving significant evidence of his opinion of Turner's eminence.

47 *Tabley, windy day* 1808

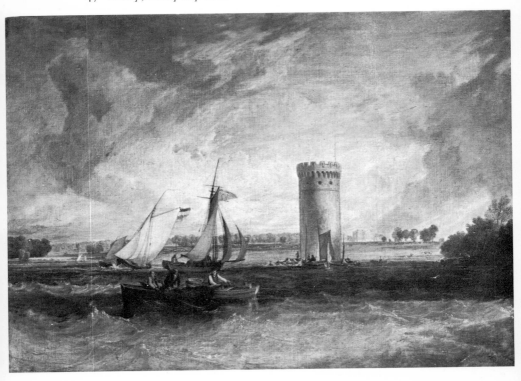

48 *Otley, from Caley Park*, a page from the sketchbook of *c.* 1812 used at Farnley

The following year Turner travelled on similar commissions – to Lowther Castle, in Westmorland, to paint two views for Lord Lonsdale, and southward to Sussex to paint a view of Petworth for Lord Egremont. Lord Egremont, the perfect type of an aristocrat 'with much more knowledge upon all subjects than he chooses to pretend to', simple, kind and gentle, was an earlier and remained a more constant patron of Turner than Sir John Leicester. After this visit Turner was frequently invited to stay at Petworth, more particularly in the 1830s.

Another relationship which began by the purchase of paintings and ended in a warm friendship was that with Mr Walter Fawkes of Farnley Hall, in Wharfedale, Yorkshire. Mr Fawkes first bought a watercolour of Turner's in 1803. Turner visited Farnley Hall in 1810, and thereafter made frequent visits till Fawkes died in 1825. He became an intimate friend of the family and his company was valued as much as his art: here he seems to have been at his most relaxed, grouse-shooting and playing with the children.

All these visits gave new motifs for his art. But the valley of the Thames still remained at the centre of his affections. When

69

he first moved up the river, taking his house on Hammersmith Mall in 1807, he lived there with his father, giving up part of his house in Harley Street but maintaining the gallery there. In his garden at Hammersmith he had a summer-house, in which he painted, and where he could watch the river scene. This was the prelude to a move further up the Thames. In 1811 he left Hammersmith for Sion Ferry House, near Sion House, Isleworth; from here he superintended the building of his own house on land he now owned. He first called this Solus Lodge in reference to his pressing desire for solitude, but changed the name to Sandycombe Lodge. His father was again an important part of this new household. He took charge of business affairs, acted as studio hand and factotum, and was fiercely jealous for his son's interests. The bond between the two men had been a strong one ever since Mrs Turner's illness.

49 *Windsor c.* 1809

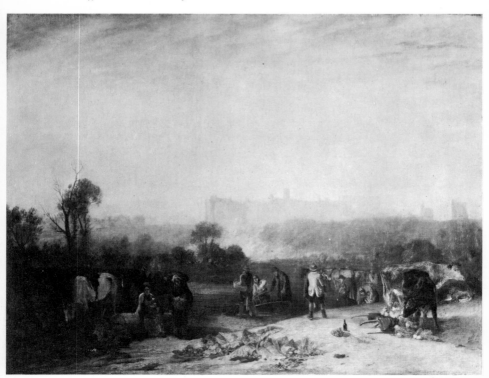

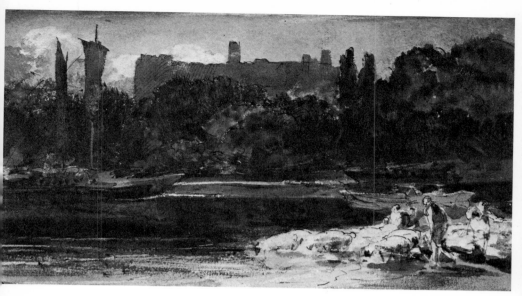

50 Study for *Windsor Castle from the river*, a painting now at Petworth,
c. 1805–6

To get an even more comprehensive insight into the river's
course Turner seems to have hired a boat, from which he made
drawings and open-air paintings. The oil sketches he made in
this period occupy a distinctive place in his work. It was unusual
for him to paint plein-air oils. Indeed, when taxed in Rome by
someone who wanted to go out colour-sketching with him,
'he grunted for answer that it would take up too much time to
colour in the open air – he could make 15 or 16 pencil sketches
to one coloured'. We need not take this too literally, for
coloured drawings painted in the presence of the motif recur
throughout his life. But oils so constructed are unusual, and the
group of sketches, many made on the Thames, is the one
significant body of them in his earlier period.

The precise date of these works is a matter of some interest.
The present consensus places the inception of these oil sketches
at about 1806.

51 Study for *The Sun rising through vapour c.* 1800–5

52 *The Sun rising through vapour* 1807. Bequeathed, with *Dido building Carthage*, 'to hang between two Claudes'

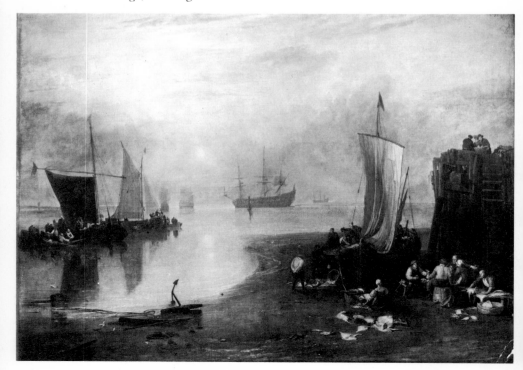

53 *Men with a windlass, drawing a fishing-boat out of the surf c. 1796–7*

54 *Calais Pier, with French poissards preparing for sea: an English packet arriving 1803*

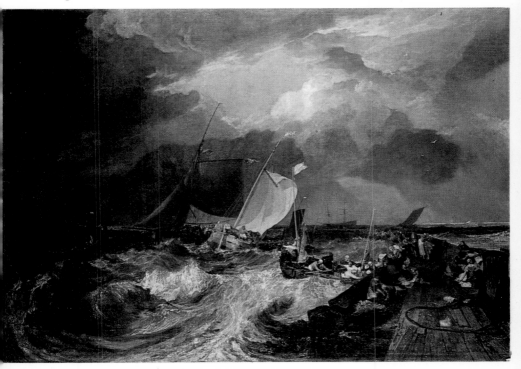

It was in this year, 1806, that Sir John Leicester bought a painting of *Walton Bridges* which is one of the subjects of the *Ill. 57* sketches. The suggested dating is consistent with Turner's move to a position close beside the river in 1807. It would coincide with the increase in Thames subjects in his exhibited oils at the time, including the *Thames near Windsor* of 1807, *Eton College from the River* of 1808 and *Near the Thames' Lock, Windsor* of 1809, all of which were bought from Turner's gallery by Lord Egremont. It would tally with Benjamin West's report of his visit to the gallery in May 1807, after which he told Farington that he was 'disgusted with what he found there; views on the Thames, crude blotches, nothing could be more vicious'. Like many other distinct phases of Turner's art, however, the point is conjectural.

If these are correctly assigned to the years 1806 and 1807, Turner is in some respects anticipating the breakthrough to the free and more naturalistic form of oil sketch painted in the open air which Constable, after much groping, first achieved in his own art, so far as we know, in 1808. We are not told that Turner showed anything so intimate and unfinished in his

55 *The artist* 1809. Study for a pendant to *The Garreteer's Petition*, which was exhibited at the Royal Academy in 1809

gallery, but if he did their presence may have been a stimulus to Constable in his search. But equally this may be another example of two artists hitting upon a similar solution to common problems. And indeed the resemblance is a superficial rather than a deep one. Turner's sketches are painted on thin mahogany panels which act as a unifying ground for the tone of water, vegetation, and sky in the same way as Constable's Venetian-red background derived from the seventeenth-century masters. The local colours, the greens of the trees, and blues of the skies, are naturalistically rendered, and form is suggested rather than precisely defined in both cases. But while Constable's are the product of a long and detailed contemplation of his Suffolk homeland, Turner's, surprisingly free as they are from his usual passion for atmospheric regression, are quick apprehensions of their casually selected subjects.

As if he were not fully enough occupied with keeping his own gallery stocked with oil paintings, Turner began at this time to be more deeply concerned in the engraving of his works. The ambitious project of a large mezzotint plate from *The Shipwreck*, bought by Sir John Leicester in 1805, had been

56 *A road and trees beside a river.* Page from a sketchbook containing studies connected with the *Liber Studiorum c.* 1809–10

carried out. It was engraved on a grand scale, 33 by 23½ inches, and was heavily subscribed, making Turner as a marine painter far more widely known than exhibitions alone could do.

After this Turner himself acted as publisher and editor of a series of prints. He was encouraged to take this step, in spite of some misgivings, by his friend W. E. Wells, a watercolourist of indifferent accomplishment, but a dynamic organizer. Wells had founded the Water-Colour Society to assist his own branch of the profession, and is said to have suggested to Turner the
Ill. 58 opening of his own gallery. Now in 1806 he said, 'For your own credit's sake Turner you ought to give a work to the public which will do you justice – if after your death any work injurious to your fame should be executed, it then could be compared with the one you yourself gave to the public.' After

much hesitation Turner replied (in words recalled forty-six years after the event by Wells' daughter), 'Zounds, Gaffer, there will be no peace with you till I begin . . . well, give me a sheet of paper there, rule the size for me, tell me what subject I shall take.'

This in substance, though with possible legendary embellishment, was the inception of the *Liber Studiorum*. It was suggested by Claude's *Liber Veritatis*, a book of drawings in which he recorded the composition of all his paintings, to prevent dissimulation. This had been engraved in a warm sepia imitating Claude's wash medium by Richard Earlom, and these prints suggested Turner's plan. But Turner was not aiming to provide an illustrated catalogue of his extant work. While he included some executed compositions in the plates he came to use the

57 *The Thames near Walton Bridge,* one of a series of studies made in the open air, probably in 1806 and 1807

series as an exercise in revealing the different categories of landscape, and his facility in encompassing them all. Accordingly a classification of landscape was arrived at, which comprised the following divisions: History, Mountains, Pastoral, Marine, Architecture, and a category which Turner did not explain, giving it the initials E.P. This has been interpreted variously as Epic Pastoral, Elegant Pastoral, or Elevated Pastoral. The classes, though they may overlap, enumerate most of the different types of work in which Turner engaged. 'History' included subjects of historical painting such as *The fifth plague of Egypt*, of which he used the design for one of the plates. 'Mountains', by now a prominent subject in his art, were represented by *The Little Devils' Bridge* and other Swiss scenes. 'Pastoral' included *The Straw Yard* and *Farmyard with the Cock*.

In 'Marine' he included his earliest successful oil painting, *The Cholmeley Sea Piece* of 1796, and an emphatic stormy *Coast of Yorkshire near Whitby*. 'Architecture' comprised some topographically rendered buildings and townscapes, *London from*

58 *Wells' Kitchen, Knockholt c.* 1806–7, drawn on the visit when Wells suggested to Turner the idea of making his *Liber Studiorum*

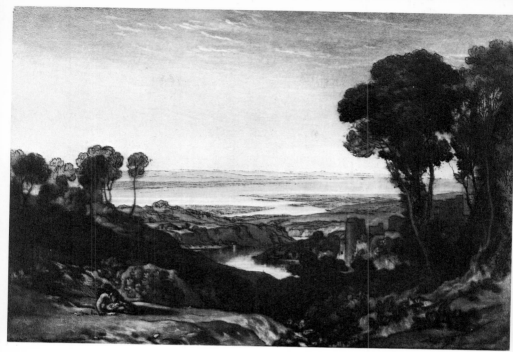

59 *Junction of Severn and Wye*. Etched and engraved, in mezzotint and aquatint, by Turner for his *Liber Studiorum*, 1811

Greenwich as well as *Holy Island Cathedral*. And 'Epic Pastoral', if that is the meaning of E.P., encompassed not only Turner's favourite view of Isleworth, the *Junction of Severn and Wye* and a plate called *Solitude*, but also the Claudean *Bridge in middle distance*. The scheme reveals the vast ambition Turner entertained for the art of landscape painting as a whole.

Ill. 59

For technique Turner chose a method which might give comparable results to Earlom's prints, but in which he could exercise control over the engraver. Accordingly he prepared pen and sepia, or bistre wash drawings, etched the outlines himself, and hired professional engravers to supply the areas of tone, in mezzotint or aquatint. The plates were then printed in a warm brown ink imitating the colour of the drawings, as Earlom had done. Turner intended to produce one hundred

prints, and did produce seventy-one between 1809 and 1819, when lack of support caused him to abandon the project. While the first thoughts for plates in the series are among the most

Ill. 56 spirited of Turner's drawings, the finished models for the engraver have some of the dullness of uniformity, and this is still more true of the plates themselves. Perhaps they evoke a sense of disappointment because they rely too strongly on the design, the bare bones of composition and the topographical facts of landscape, omitting the atmospheric veil which Turner casts over his best work.

Though the attempt to be his own publisher had failed, Turner did not scorn the help of the engraver in popularizing his art. In fact this became a major source of activity and income for him. But in future, engravers or publishers commissioned his drawings and undertook the risk. Turner kept a close watch on the quality of the plates, and by his instruction trained up a school of highly skilled reproductive craftsmen, much as Rubens had done. The first big undertaking of this kind was a series of forty drawings commissioned by W. B. Cooke in 1811 for a publication entitled *Views of the Southern Coast of England*. To gather material for it Turner set out that July on a sketching tour such as he had hardly undertaken for nine years. He spent two months in the West Country, Dorset, Devon, Cornwall and Somerset, making over two hundred pencil sketches. It appears to have been on a later tour that he made some of the

Ills. 60, 72 studies which he elaborated into *Crossing the brook*.

Turner did not make all the drawings for Cooke's 'Southern Tour' but he made the greater number of them, and he covered the coast from Margate, round by Poole to Land's End and further, to Tintagel and Minehead. The drawings he made were translated into line engravings, under Turner's watchful supervision, and the prints are remarkably successful in preserving the light and atmosphere of the original conceptions. Publication began in 1814 and continued until 1826. The part they played in spreading a knowledge of his style is shown by the episode of Dr Waagen, the director of the National Gallery

in Berlin, who made so thorough a study of the paintings in British collections. On his arrival in England in 1835 he sought out Turner's works at the Academy – they were a particularly strong group, which included *The burning of the Houses of Lords and Commons, October 16, 1834, Keelmen heaving in coals by night* and *Ehrenbreitstein* – but was disappointed by them in comparison with the engravings, which he had long admired. *Ills. 142, 143*

The venture with Cooke ended in a disagreement, and the publisher wrote Turner a somewhat intemperate letter accusing him of breach of faith. But Cooke placed the drawings he had bought for engraving on exhibition and sold them well. No doubt Turner's thoughts about publishers were similar to those expressed by Dickens to William Holman Hunt: 'Yes, we inspired workers for public entertainment ought to think of nothing so much as the duty of putting money into publishers' pockets, but we are a low-minded set, and we want a part of this filthy lucre for ourselves, for our landlords and our tradesmen, who most unfeelingly send us in bills as though we did nothing for their pleasure.'

While in the West Country, Turner called on some of his father's family in Barnstaple and in Exeter. As well as travelling all round the coast, he compiled a lengthy rhymed account of the places he visited, which he interleaved in his copy of the

60 Two pages from a sketchbook used by Turner in Devon, especially at Plymouth and on the Tamar, in 1812 or 1813. One of several drawings probably connected with *Crossing the brook*

guide-book he was using, Coltman's *The British Itinerary*. In displaying his robust patriotism, these verses reveal a genuine sympathy with the poor and their occupations: the making of Bridport twine, the fisherman's wife whose husband has been captured while seeking lobsters beyond the usual fishing-beds.

The problems of self-expression were preoccupying Turner in this period. He had been appointed Professor of Perspective at the Royal Academy in 1807; in 1811 he had at last begun to deliver his course. It consisted of six lectures. His method of delivery was unfortunate; Redgrave recorded that 'half of each lecture was delivered to the attendant behind him', who was showing the magnificent range of drawings and diagrams Turner had assembled for the purpose. (Stothard, who was completely deaf, attended to see these drawings alone.) Though the train of thought is confused, the notes Turner has left show that he had read and thought deeply about his subject, and had a full grasp of the intricacies, even if he could not convey this to others. At the same time he took the opportunity to go beyond the technicalities of his subject and express more general views on painting and on poetry. This he did in the lecture which he called 'Backgrounds', in which he gave a résumé of the history of landscape painting and expressed enthusiasm for Claude and other forerunners.

Concurrently with the emulation of other masters and the purely pastoral or typographical themes, Turner was at work

Ills. 61, 62, 64

61 Turner's diagram of a Doric frieze and cornice, showing perspective projection, *c.* 1811

on a more personally conceived type of epic painting. A
growing preoccupation with ruin, sudden and complete
disaster, was dramatically expressed in a painting 'not in his
usual style' he showed at his own gallery in 1810, the *Cottage
destroyed by an Avalanche*. It is a scene set in the Grisons,
interpreting more lines in Thomson's *Winter*:

Ill. 63

> *Oft, rushing sudden from the loaded cliffs,*
> *Mountains of snow their gathering terrors roll,*
> *From steep to steep, loud thundering down they come,*
> *A wintry waste in dire commotion all;*
> *. . . hamlets sleeping in the dead of night*
> *Are deep beneath the smothering ruin whelmed.*

Turner's power and originality can be understood by comparing
this with De Loutherbourg's *Avalanche*, painted in 1804 and
also hanging in the Tate Gallery. De Loutherbourg's picture
is in worthy continuance of the eighteenth-century tradition,
Wilson's lyricism modified by a theatrical presentation.
Drawing on his Swiss travels for the topographical facts, Turner
has communicated the overwhelming force of the natural
disaster as much by the ruggedness of his handling of the paint
as by the contrast in size between the vast crashing boulder and
the small crushed cottage on the mountainside. The sublimity
and horror are reinforced by the low tone, and the almost
grisaille quality of the pigment.

62 The same
frieze and
cornice without
construction
lines and
washed with
cast shadows,
c. 1811

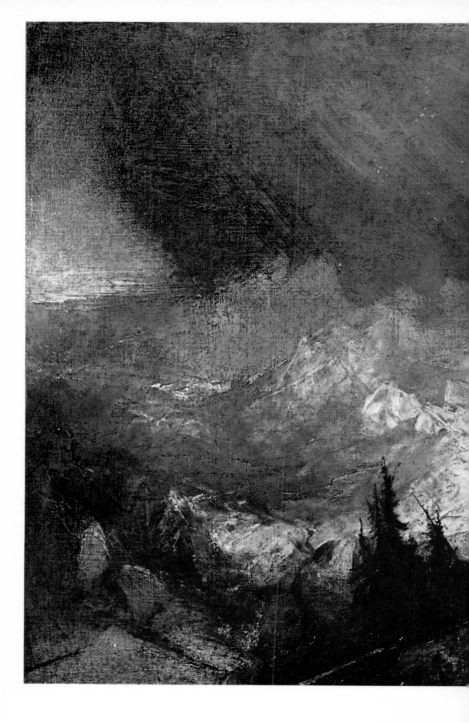

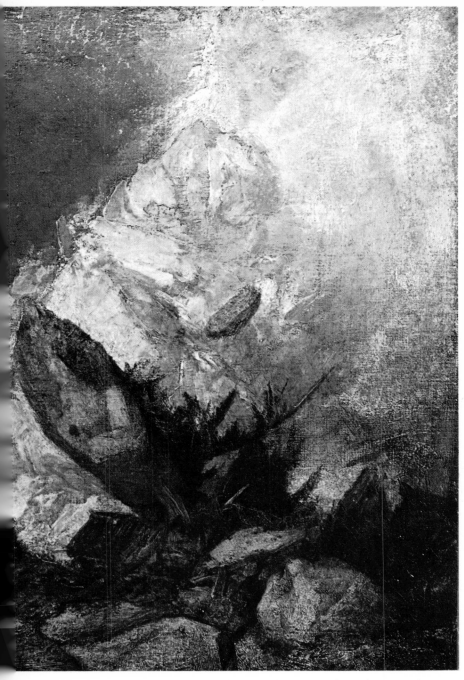

63 *Cottage destroyed by an Avalanche (Fall of an Avalanche in the Grisons)* 1810

In 1812 he first published lines from the *Fallacies of Hope*, the poem which best expressed the pessimistic movement of his mind. The occasion was the catalogue entry for the painting *Ill. 65* *Snowstorm: Hannibal and his army crossing the Alps*, which was greatly admired at the time of its exhibition and has usually been regarded as a key picture in Turner's development. The theme of these verses is disappointed ambition. In them Turner makes an analogy between Carthage in the days shortly before its collapse and Britain, a theme which was beginning to impress him at this stage of the long Napoleonic wars. They read:

> *Craft, treachery, and fraud – Salassian force,*
> *Hung on the fainting rear! then Plunder seiz'd*
> *The victor and the captive, – Saguntum's spoil,*
> *Alike became their prey; still the chief advanc'd,*
> *Look'd on the sun with hope; – low, broad, and wan;*
> *While the fierce archer of the downward year*
> *Stains Italy's blanch'd barrier with storms.*
> *In vain each pass, ensanguin'd deep with dead,*
> *Or rocky fragments, wide destruction roll'd.*
> *Still on Campania's fertile plains – he thought,*
> *But the loud breeze sob'd, 'Capua's joys beware!'*

The note of menace and gloom implied by the poetic caption is fully borne out by the pictorial content of the painting. The

64 One of a series of drawings for the lectures on perspective in which Turner explored the mutual reflection of glass spheres filled with water

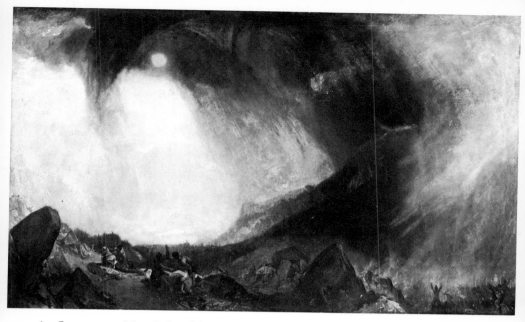

65 *Snowstorm: Hannibal and his army crossing the Alps.* Exhibited at the Royal Academy in 1812

theme had been treated by J. R. Cozens in his only known oil painting, which Turner said had impressed him deeply. To these impressions he added his reading of Goldsmith's *Roman History*. Goldsmith emphasizes the terror with which the Alps inspired Hannibal's army, and the fearful losses sustained from the elements and from the harassment of the hostile mountain inhabitants. All these ingredients Turner has combined in his gloomy and majestic scene: the menace of the mountains, the wildness of the storm, and the plundering natives represented by the group struggling over a captive woman and the booty in the foreground. To its main theme of an army on a high place looking down into a valley below, Turner has added the swirling effect of a storm he had observed a year or two before on the Yorkshire Dales. The long-remembered idea from Cozens, the observation of nature in the raw among the Swiss Alps and in the Yorkshire thunderstorm and Turner's own

87

66 *Bolton Abbey, Yorkshire c.* 1812–15

political, perhaps even personal, apprehensions, coalesce in a work which has an uncanny authority. In it, he continued and brought to a new originality the painting of disaster which he had begun in *The fifth plague of Egypt*.

For his identification of the Punic Wars with the England of his own time he found warrant also in Goldsmith's description of Carthage:

> Its chief strength lay in its fleets and commerce: by these its riches were become immense; and by means of money alone, the citizens were capable of hiring and sending forth armies to conquer or to keep their neighbours under subjection. However, as they had been long in possession of affluence, the state began to feel the evils that wealth is too apt to produce.

He combined this feeling of menace with his enthusiasm for the *Aeneid* in his later Carthaginian paintings.

In a correspondence of 1811 with his publisher John Britton, Turner had protested against Fuseli's description of landscape

67 *Frosty Morning* 1813

painters as the 'mapmakers, the topographers of art'. His most
successful exhibit of 1813, *Frosty Morning*, is an absolute *Ill. 67*
protest against the labelling of landscape as map-making.
Based upon an experience of one of his travels in Yorkshire,
which he had sketched *en route*, it interprets the visible facts at
the start of a bitter, sunny day in winter by the action of the
human beings in it, the hedgers and ditchers starting work in
the fields and the approaching stage-coach with its light still on.
Both the horses are studied from his own favourite nag, and
the shivering little girl is said to resemble his illegitimate
daughter, Evelina. To the title he added a quotation from
Thomson's *The Seasons*: 'The rigid hoar frost melts before his
beams', and with his sharp eye and finely sensitive instinct for
gradation of colour he has represented the ground dusted with
the white frost in the shadows and the brown mud where it has
begun to thaw. The sun is rising, but has not broken through
the mist, and the effect of winter is enhanced by the sharp
silhouettes of the figures no less than the leafless trees and the
foreground weeds coated with rime.

89

His journeys to Yorkshire were a great solace to him at this period. From the time he first visited Fawkes' home at Farnley Hall in 1810 he and his host were in immediate sympathy with one another. Here he enjoyed sharing in family life, and clearly found his host's Radical politics sympathetic. It was a relief from the tension he felt in London to go shooting on the Dales. It seems possible that his liaison with Sarah Danby finished in this period, though, with his habitual secrecy, Turner so successfully covered his traces that we cannot be certain that this is so.

The critics of the 1813 Exhibition and the public preferred his English landscape to the essay in the grand manner, and *Frosty Morning* has always been regarded as one of the peaks of his achievement. The contemporary view of it is well shown by the letter written by John Fisher to Constable, praising his friend's painting but saying that he, like Napoleon, is beaten by a frost. It was in the same year that Constable met Turner for the first time, sitting next to him at a dinner at the Royal Academy. The relations between these two landscape painters must have been delicately balanced and were not always unruffled, but on this occasion the meeting was a success, and Constable reported, 'I was a good deal entertained with Turner. I always expected to find him what I did. He is uncouth but has a wonderful range of mind.' The encounter might have been more awkward because Sir George Beaumont, whose protégé Constable was, had been actively campaigning against Turner's works. According to the accounts in Farington's diary, the barrage of criticism was reaching a climax at about this time. Callcott, a painter who was then coming into prominence and who was regarded as a follower of Turner, had refused to exhibit at the Academy in 1813; he attributed this to the abuse of his paintings by Beaumont and his friends which had prevented him making any sale in the previous year. Turner had by the prudent management of his earlier success put himself beyond financial disaster from such a course, but his sales from exhibitions do seem to have greatly declined. He was, too, deeply sensitive to criticism.

90

69 *Dido building Carthage; or the rise of the Carthaginian Empire* 1815. Turner valued this above all his other productions

68 Study for Turner's favourite Carthaginian theme, associated with *The decline of the Carthaginian Empire (Ill. 70) c.* 1815–16

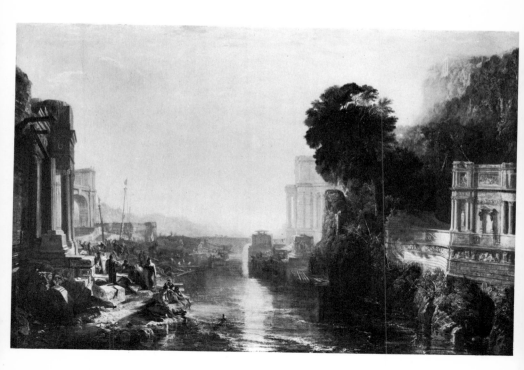

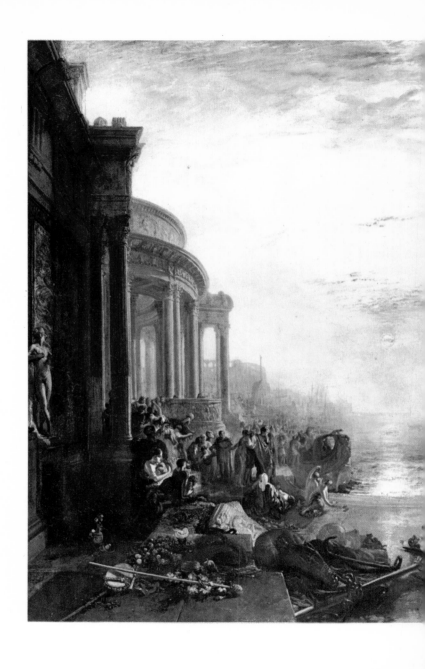

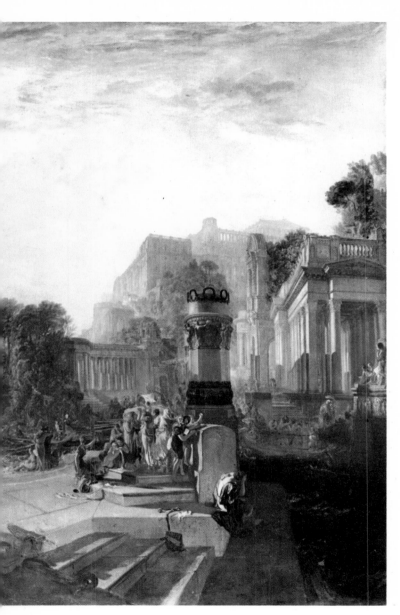

70 *The decline of the Carthaginian Empire* 1817

His alertness to the emergence of other talent challenging his own must have been accentuated during the second decade. In spite of the challenge of *A country blacksmith disputing*, Wilkie had gone on to establish himself as supreme in the field of genre; and a follower of Wilkie, Bird, was also receiving lavish praise. Both artists were greatly noticed in 1812, and *Snowstorm: Hannibal and his army crossing the Alps* was not the only attempt at the romantically sublime that year. Fuseli showed his sketch for *Lady Macbeth with the daggers*, and at the same exhibition John Martin revealed in *Sadak searching for the waters of oblivion* that he had learned from, and would try to surpass in exotic agony, Turner's vein of epic history.

The development of his treatment of historical themes had deepened since he had begun with his emulation of Poussin in *The fifth plague of Egypt* in 1800. Progressing through *The tenth plague of Egypt* in 1802, and *The destruction of Sodom* of 1805, he had made a series of studies of disasters which are theatrical and stirring to the senses. The outstanding success of *Hannibal crossing the Alps* springs from its combining his own feelings of anxiety with his personal vision of the wild mountain scenery and the disturbing storm. This personal emotion is carried into the Carthaginian scenes, in particular the monumental *Dido building Carthage; or the rise of the Carthaginian Empire* of 1815 and *The decline of the Carthaginian Empire* of 1817. The aspiration which he put into the former is shown by his leaving it to the nation with the condition that it be hung between two Claudes, the *Sea Port* and *The Mill*.

Dido building Carthage, which Turner regarded as his *chef d'œuvre*, was painted the year after he had made a more literal paraphrase of Claude, the *Appullia in search of Appullus*. This was most directly founded on Claude's *Transformation of the Apulian Shepherd* at Bridgewater House, and was painted with a deliberate purpose in view. He entered it for a competition for the best landscape painting appropriate in subject and in manner as a pendant to a work by Claude or Poussin. This was organized by the British Institution, and since one of the judges was Sir

Ill. 43

Ill. 65

Ill. 28
Ills. 29, 35

Ill. 69
Ill. 70

Ill. 71

George Beaumont, Turner evidently intended to tease his antagonist by sending as close an imitation of his most revered artist as he could make without sacrificing his own originality. The painting was not placed first, and the premium was given to the clearly inferior painter Hofland; but the gesture was successful in proving that there was a real prejudice against Turner. It would be interesting to know if it was of this picture that Beaumont made the remark recorded by Constable in his last lecture on landscape: 'Sir George Beaumont, on seeing a large picture by a modern artist, intended to be in the style of Claude said, "I never could have believed that Claude Lorraine had so many faults, if I had not seen them all collected together on this canvas." ' Certainly Beaumont demonstrated that he had the courage of his convictions in the following year by

71 *Appullia in search of Appullus.* Exhibited 1814

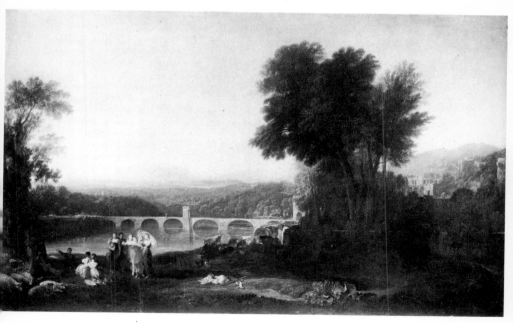

Ills. 69, 72

returning to consider Turner's two works: *Dido building Carthage* and *Crossing the brook* in the light of the almost entirely enthusiastic reception they had received. He decided that he could not change his view and that Turner painted 'in a false taste'.

However, he had begun to over-reach in his criticism, and a spirited counter-attack upon him and his fellow directors of the British Institution, Holwell Carr and Payne Knight, was contained in an anonymous pamphlet published in 1815. The authorship remains uncertain, but it was clearly an Academician friendly to Turner. The chief complaint was that the amateurs of Old Master painting were setting up a dictatorship in taste and decrying genuine modern originality in favour of an archaistic style of imitation. It is a familiar complaint of the artist against the patron, and Beaumont was quite justified in claiming the right to his own judgment. Where he seems to be at fault is in asserting that Turner's work in oil was simply the translation into an inappropriate medium of his style in watercolour; and it is strange that Constable should have followed Beaumont in making this particular technical criticism. As in his first essays in oil, Turner learned from the other mode of painting, but he is deeply responsive to the different capacities and technical resources of either.

It was shortly going to be possible for the public to judge this matter for themselves. In 1819 Sir John Leicester put on public display at his house in Hill Street the collection of his paintings by modern British artists, including eight oil paintings by Turner. Among these were the two views of Tabley Park,

Ills. 43, 52

A Blacksmith's Shop and *The Sun rising through vapour*. Shortly afterwards Mr Fawkes invited the public to see his collection of watercolours, also by modern British artists. By far the greater number were by Turner: sixty or sixty-five out of a total of eighty-five or ninety. Fawkes, a patron of Turner's since 1803, had recently brought his collection thoroughly up to date by the purchase of the complete set of some fifty watercolours which Turner had based on a visit he made to the Rhine in 1817,

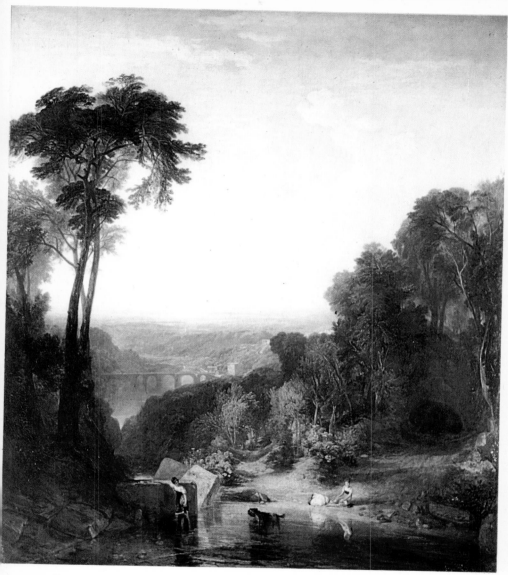

72 *Crossing the brook*. Exhibited at the Royal Academy in 1815

73 *Dort or Dortrecht: The Dort packet-boat becalmed* 1818

the first visit he had paid abroad since his tour of France and Switzerland in 1802.

While Leicester's exhibition contained nothing later than 1809, the range of watercolours exhibited by Fawkes extended from those of the first Swiss tour which he had bought in 1804 to the latest product of the Rhine tour of 1817. Between these limits were a number of English scenes, mainly of Wharfedale and other Yorkshire views near Farnby. In them the full degree of Turner's liberation from the reticent formality of eighteenth-century watercolour is apparent. The Yorkshire scenes, such as the views of Bolton Abbey, are pervaded by a warm sunlight on vegetation, which gives them the tones of olives and honey. The Rhineland scenes, in which a prevailing unity of tone is

achieved through the grey wash laid over the white paper, show all the measure of his sense of aerial perspective; their content is atmosphere and foreground clutter.

Fawkes had also bought for his collection the most highly praised of Turner's sea-pieces, the *Dort or Dortrecht: The Dort* *Ill. 73* *packet-boat becalmed*, which he had exhibited at the Royal Academy in 1818. And it is from Farnley Hall that we have the most direct and first-hand account of Turner's swiftness and decision when painting his watercolours; an account which is all the more valuable because he was habitually so secretive about his methods. The story, frequently recalled by Walter Fawkes' eldest son, Hawksworth, was thus recorded by his niece:

74 *First Rate Taking in Stores* 1818

I have heard it repeatedly stated by all the generation who were children when Turner was so much at Farnley . . . that, with one deeply interesting exception, no one ever saw him paint when he was there. The exception was this – one morning at breakfast Walter Fawkes said to him 'I want you to make me a drawing of the ordinary dimensions that will give some idea of the size of a man of war.' The idea hit Turner's fancy, for with a chuckle he said to Walter Fawkes' eldest son, then a boy of about 15, 'Come along Hawkey and we will see what we can do for Papa', and the boy sat by his side the whole morning and witnessed the evolution of the 'First Rate Taking in Stores'. His description of the way Turner went to work was very extraordinary; he began by pouring wet paint onto the paper till it was saturated, he tore, he scratched, he scrubbed at it in a kind of frenzy and the whole thing was chaos – but gradually and as if by magic the lovely ship, with all its exquisite minutia, came into being and by luncheon time the drawing was taken down in triumph. I have heard my Uncle give these particulars dozens of times . . .

Ill. 74

75 *'Plantain, Nettle, Cat's Tail, Daisy'*. Study of wild flowers from a sketchbook used on the Thames *c.* 1815–17

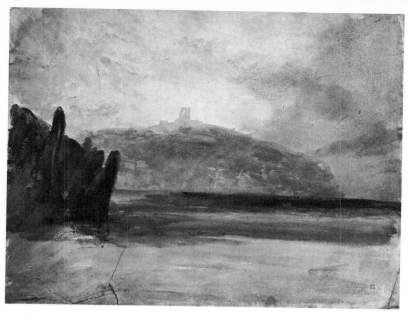

76 *Scarborough*, said to be a study for a watercolour exhibited in 1811, but probably a later return to the theme

An earlier version described how Turner 'tore up the sea with his eagle-claw of a thumb-nail . . .'. This we can recognize has the marks of truth. It focuses attention on Turner's fantastic visual memory, on his powers of swift decision, on the actual physical strength he used up in the activity of painting, and on the speed of his creative spurts. The episode links well with the public displays of painting he gave at a succession of 'varnishing days' at the Royal Academy, when he began with what was apparently a lightly stained canvas and brought it rapidly to completion. It is partly in the context of the sense of energy in his individual pieces, and in the wide range of subjects he painted, that we should judge the self-pity, the hope disappointed and the political pessimism expressed in his verses in the *Fallacies of Hope*. While he undoubtedly had a tragic sense of life which deepened as he grew older, his writing was often undertaken in moods of reaction, when he had exhausted his energies in concentrated and decisive painting.

77 *Study of shipping, Scarborough c.* 1816–18. Almost purely conceptual, it looks like a child's scribble, but Turner's powerful visual memory could build on rapid notes of this kind

78 *Watchet, Somerset.* Page from a copy of Coltman's *British Itinerary*, interleaved with blank sheets, which Turner used for sketches in the West Country in 1811

79 *The field of Waterloo,* from a sketchbook used when travelling to the Rhine in 1817

80 *A Man galloping on the sands at Scarborough c.* 1816–18. From the same sketchbook as *Ill. 77*

81 *A bridge in the West Country over a rocky stream.* One of a group of eleven oil sketches made in Devonshire *c.* 1812–13

82 *View of the Temple of Jupiter Panellenius, in the Island of Aegina, with the Greek National Dance of the Romaika: the Acropolis of Athens in the Distance* 1814. Painted from a sketch by H. Gally Knight

84 *A colour sketch* 1818–20

Technically he was, as Hawksworth Fawkes' description shows, always alert to the possible extension of the watercolour medium's powers. Already in 1817 he had made, amongst the Rhine drawings, the *Mainz and Kastell*, in which the sky is composed of blobs of colour run on damp paper, and he uses his fingerprints freely. These are all anticipations, or first indications of the liberation to be seen in the 'Colour Beginnings' which are generally assigned to a decade or two later.

Over the watercolours as a whole there is an informality of composition which is both cunning and original. Even in the most ambitious of these drawings Turner is thinking little about what he has learned from Poussin and Claude; still less is he making pastiches of them. The oils of the same fifteen years, as we have seen, depend more heavily on the past, the catastrophe pictures on Poussin, the marines on Van de Velde or Cuyp, the

105

83 *Schloss Stolzenfels, with the village of Capellen below* 1817

85 *Sketches of buildings and trees at Raby Castle c.* 1817

Carthaginian pictures on Claude. There is an originality in one defined group of British topographical oils: the series which
Ill. 49 includes the *Windsor* of 1809, *Petworth* of 1810, *Somerhill* of
Ill. 87 1811, and *Raby Castle* of 1818. In all of these the central subject is the impressive mass of a building, presented in such a way that the real theme of the painting is in the veils of atmosphere and mist. Two other works stand out with special distinctness.
Ill. 72 *Crossing the brook* succeeds in a remarkable degree in combining the structure of a Claude with an unusual greenish-brown tonality and the facts of the Devonshire landscape. *England :*
Ill. 86 *Richmond Hill, on the Prince Regent's Birthday*, the largest painting Turner ever made, is more directly Claudean, but by its *brio* and the animation of its figures makes an affirmation about the Thames Valley, worthy of Turner's devotion to this subject.

Frosty Morning, Crossing the brook, and *England : Richmond Hill* have an emotion evoked by the associations of their subjects. It was in the period between the exhibition of the two latter that Hazlitt made his comment about Turner's work being 'pictures of nothing and very like'. The remark has astonished

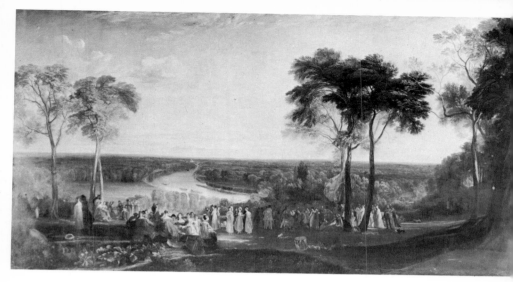

86 *England: Richmond Hill, on the Prince Regent's Birthday* 1819

87 *Raby Castle, the seat of the Earl of Darlington* 1818

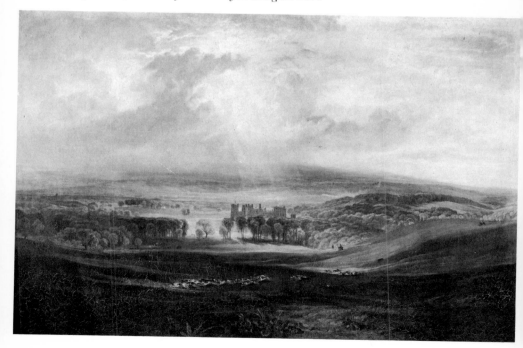

88 *Thames from Richmond Hill.* Classified by Finberg among the 'Colour Beginnings'. Perhaps a colour sketch for *Ill. 86*

later generations because it anticipates Turner's last works of all, but now seems hardly relevant to those he had produced by 1816. But it is worth looking at a sentence which precedes this phrase, '. . . whose pictures are however too much abstractions of aerial perspective, and representations not properly of the objects of nature as of the medium through which they were seen'. Faced with a large group of works produced at one time, such as the watercolours from the Rhine scenery, a critic might feel that the artist was manipulating the elements of the scene without a deep involvement in the place depicted. These serial views are to be regarded as 'abstractions' – manipulations, without great feeling, of the elements of the scenery; but *England: Richmond Hill* was not. And it was fitting that Turner should have shown this carefree embodiment of his love of his country at the RA in 1819, shortly before setting out to visit Italy for the first time.

Italy: 'That veil of matchless colour'

Turner's visit to Italy in 1819 at the age of forty-four was the culmination of a long process of preparation. This had begun when he had helped to copy the drawings of John Robert Cozens at Dr Monro's house, and been fostered by the constant attention he had paid to Poussin and Claude. When he first went to the Continent in 1802 he penetrated as far as the Swiss Alps, but did not then cross the border into Italy. During the years in which he did not leave his own country the urge to go further south had been building up. The tour of the Rhine he undertook in 1817 was a consolation for a trip to Italy he had postponed for two years running. Then in 1818 he had the task of making up watercolours of Italian scenes, from *camera lucida* sketches which had been made by James Hakewill as an aid to the illustration of his narrative *Picturesque Tour of Italy*. With the resounding success of his paintings at the exhibitions mounted by Leicester and Fawkes, and a comparative relaxation of his engagements for publishers, Turner was encouraged to set out. At the same time Lawrence, who was in Rome making his portrait of Pius VII for the Waterloo Chamber, added his inducements. He wrote to Farington to urge the journey on him: 'Turner should come to Rome . . . the subtle harmony of this atmosphere, that wraps everything in its own milky sweetness . . . can only be rendered, according to my belief, by the beauty of his tones.' He added that looking at the country he thought always of Turner's paintings, less often of Claude, still less of Gaspard Poussin. Turner embarked on his journey at the beginning of August.

He was in search not simply of scenery, picturesque, pastoral, or sublime, such as he had already digested into his art. He was

also in search of history, of the Italian past and the paintings of Italian masters. And it is clear from his future productions that Italian cities made a profound impact on him. Most of all, it was the Italian light, the 'atmosphere that wraps everything in its own milky sweetness', of which Lawrence had written, which gave such a new impetus to his art.

Ill. 90　　He crossed into Italy by the Mont Cenis pass, and after seeing Turin, Lake Como and Milan, paid his first and very impressionable visit to Venice. Then he travelled to Rome by way of Bologna and Foligno. In his sketchbook he made minute notes about the colour of the hills and the olive groves – 'the ground reddish green-grey and apt to Purple, the Sea quite Blue, under the sun a warm vapour, from the Sun Blue relieving the shadow of the olive trees dark, while the foliage light or the whole when in shadow a quiet Grey'. At Loreto he noted *Ill. 89*　　against a drawing in this book, 'The first bit of Claude'. Then, about mid October, he arrived in Rome. The city was full of cosmopolitan travellers, and to their presence we owe the fact that we have more personal details about Turner than are usual for his tours. There was a timely eruption of Vesuvius, and Turner left Rome to witness a spectacle so much to his taste. It was at Naples that Soane's son saw him 'making rough pencil sketches to the astonishment of the Fashionables', and noted his comment that it would take too much time to colour his work in the open air, since he could make fifteen or sixteen pencil sketches to one coloured. Certainly, he needed all the haste he could command, since he made nearly 1,500 pencil sketches in and around Rome in about two months; these slight memoranda were supplemented, as always, by his fantastic visual memory, and by the close analysis of colour revealed in the extract from the sketchbook quoted above.

When every allowance has been made for the desire of historians to draw hard-and-fast lines, it cannot be denied that Turner's visit to Italy marks the most significant turning-point in his art. It happened almost exactly half-way in his professional career,

89 *Distant view of Loreto*, inscribed '*The first bit of Claude*' 1819

90 *Turin Cathedral*, from a sketchbook used on the first visit to Italy in 1819

and at a time when his self-confidence stood high. There had already been signs of his being more deeply interested in pure colour, and the liberation of his work from tonal contrast – notably in some of the watercolours he sold to Fawkes after the Rhine trip of 1817. There was no complete break with the past after his return; such oils as *Port Ruysdael* of 1827 and the watercolours he made of Roman subjects are still conceived in the manner natural to his earlier style. But his aims had been crystallized, and his really remarkable advances towards regarding light as colour come in the second half of his career. Other aspects of his nature which had been slowly coming into being also become sharper. He had always maintained the right of the artist to complete freedom and the exercise of his own judgment, but in practice had sometimes modified his style to suit a patron. Now the categories are more distinct; he does potboilers for engraving, which maintain his income at a

91 *The Passage of Mont Cenis: Snowstorm* 1820

92 *The Colosseum, Rome* 1819. From the sketchbook used on the first visit to Italy

93 *The Roman Campagna; morning* 1819

satisfactory level, and in his exhibition pictures he goes some way towards trying to mollify outraged public taste. But these activities left him free to pursue in isolation the real goals in which he could develop an originality burning to be expressed.

Having spent Christmas in Florence he set out on his return journey to England in January. The pass was blocked by snow, but with characteristic intrepidity he set out to cross the Mont Cenis in a coach, with other travellers. This vehicle overturned at the summit and the party had to walk for the entire descent. *Ill. 91* Later on, he painted a watercolour of the scene for Fawkes. His first public acknowledgment of the excitement set up in him by his Italian trip came soon afterwards, for he sent his *Ill. 94* *Rome from the Vatican* to the Royal Academy in May 1820.

The full title of this badly received picture was *Rome from the Vatican: Raffaelle accompanied by La Fornarina, preparing his pictures for the decoration of the Loggia.* The panoramic view of the city as far as the distant hills is taken from the gallery of Raphael's *Loggia*, on to which it seems that the contents of the Vatican storeroom have been carelessly moved. The clutter of pictures includes not only the *Madonna della Sedia* but, unaccountably, a landscape by Claude, and Raphael and his mistress are rearranging the piles. As a rather touching tribute to art in the person of his predecessor it has some appeal, but it is hard to quarrel too violently with the condemnation which the picture received at the time, since Turner has here committed the obverse fault to one he condemned in his lectures, that of making the narrative action inappropriate to the architectural and landscape background. But the management of the masses is original, even for him. As well as making the subject a vast exercise in the art of perspective, of which he was still Professor, he had drawn attention to the counterpoint of curves, particularly the arch over the figures in opposition to the ellipse of Bernini's colonnade, in an unusually direct way.

Partly because of the poor reception of this painting, partly because he was rebuilding his town house in Queen Ann Street, he sent nothing to the Royal Academy in the following year.

94 *Rome from the Vatican: Raffaelle accompanied by La Fornarina, preparing his pictures for the decoration of the Loggia* 1820

And for some time after this his volume of exhibits was much reduced; one each for 1822 and 1823, none in 1824, two in 1825. Then he returned to a steadier average of four or five. Besides all his other distractions and his work for engravers, he seems to have felt the need to assimilate his Italian experience more deeply before he could make exhibitable pictures of them. His real work was being done in private. At the same time he was coming before the public in other ways. The new gallery he had built in London was opened in 1822, though it attracted less attention than exhibitions of works by West, Glover and Martin. Earlier in the year the engraver, W. B Cooke, had mounted an exhibition of drawings for sale, amongst which were a group Turner had made for his publications. This was so successful that the venture was repeated in 1823 and 1824, after which Cooke got into financial difficulties and Turner broke with him.

95 *Scarborough*, engraved for *The Ports of England*, April 1826. This is typical of Turner's finished watercolours, when highly wrought for engraving or exhibition

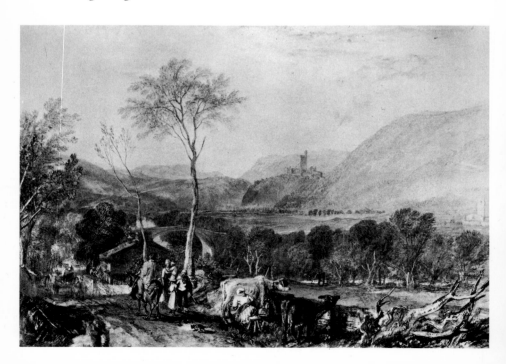

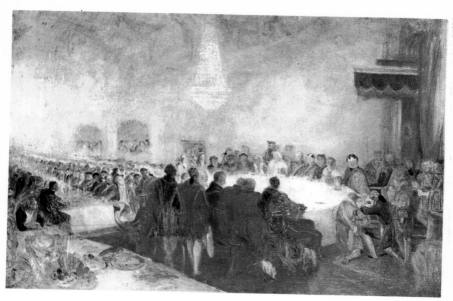

97 *George IV at a Banquet in Edinburgh* 1822

The first Italian trip had impelled Turner to think of a second, but it was nine years before he went back. In the meantime he undertook a variety of lesser excursions. Those to Farnley, the last of which was in 1824, were relaxation; the others were in conjunction with his commissions. Thus in 1822 he went to Scotland in the wake of George IV who was paying his historic Royal visit to Edinburgh. Wilkie was there in an official capacity, and much surprised to see his rival. On this trip he made sketches for the series of engravings of *Rivers of England,* but the most memorable achievement was the oil painting *George IV at a Banquet,* which he never exhibited. *Ill. 97* As an experiment in an interior scene lit by candles it anticipates Delacroix's *Assassination of the Bishop of Liège,* which was begun in 1827; and in Turner's own work it points the way towards the Petworth interiors. In the summer of 1825 he visited *Ills. 113, 114* Holland, Belgium and North Germany, and the next year he

117

96 *Hornby Castle from Tatham Church,* engraved for Whitaker's *History of Richmondshire c.* 1822

98 *Landscape with figures*, from a sketchbook of *c.* 1823–4

99 *An Avenue, with a castle in the distance*, from a sketchbook of *c.* 1822–3

100 *Red sunset on a hill fortress* connected with a tour of the Meuse and Moselle, probably that of 1826. Ruskin said of it: 'Such things *are*, though you mayn't believe it', referring to its violent colour

went to France and Germany to explore the courses of the *Ill. 100* rivers Meuse and Moselle.

These diverse experiences, added to the great stores of sketches and impressions which Turner had already formed, give an unusual variety to the work of the 1820s. After showing *Rome from the Vatican* in 1820 he returned twice to themes directly drawn from his first Italian trip. *The Bay of Baiae, with* *Ill. 101* *Apollo and the Sybil* which he exhibited in 1823, is a full-blooded essay in the mould of Claude, but with the sober range of greens and blues blending into the warmer colours which he had come to admire in the Mediterranean light. Of it Constable wrote, 'Turner is stark mad with ability. The picture seems

101 *The Bay of Baiae, with Apollo and the Sibyl.* Exhibited 1823

Ill. 26

Ill. 36
Ill. 71

painted with saffron and indigo.' In subject, it returns to his first classical venture of all, the *Aeneas and the Sibyl* painted before 1800 in the manner of Wilson, and in composition he returns again to the tree-dominated distances of *The festival upon the opening of the vintage at Macon* of 1803, and *Appullia in search of Appullus* of 1814. From the *Forum Romanum* of 1826 he chose a subject of architecture in picturesque ruin, and reverted to the types of *The tenth plague of Egypt* of 1802 and *The Destruction of Sodom* of 1805.

In the two large topographical views of ports, the *Dieppe* shown in 1825 and the *Cologne* shown in 1826, he develops a different topographical idiom. Painted on the same large scale, they now hang together in the Frick Collection and may be regarded as pendants. Both are pervaded by a high key of golden light, due in part to the tempera ground on which it appears they were painted, which caused Turner to issue urgent instructions that they should not be wetted. While they are

grandiose presentations of the northern ports, in line with the
Dort which had been so successful in 1818, Turner was at this *Ill. 73*
period more harmoniously engaged in his oils with British
landscapes. Amongst these are the pair of paintings on a smaller
scale of William Moffatt's house, Mortlake Terrace, which he *Ill. 102*
exhibited in 1826 and 1827. The motif is one which would
appeal to Turner: the lawn of a house overlooking the Thames
near his own riverside home at Twickenham. The theme of the
first to be exhibited was early morning, and the view is directed
towards the sun which is throwing long shadows across the
lawns on which, as in *Frosty Morning*, the moisture is drying.
But when he came to paint the house in the glow of a summer's
evening for the next year's exhibition he did not, as a later
generation of artists would have done, paint from the same
angle. He turned his easel round, characteristically once again
facing into the sun.

102 *The Seat of William Moffatt, Esq. at Mortlake. Early Summer's morning* 1826

Possibly as a result of the interest he had taken in George IV's visit to Scotland, Turner was commissioned in 1823 to paint a *Ill. 104* vast representation of the Battle of Trafalgar – the version, differing from the piece of 1808 in the Tate Gallery, which now hangs in the National Maritime Museum at Greenwich. Into this task he projected all his patriotism and his love of the sea, but he had a hard task trying to meet all the criticisms of the seamen who were anxious for complete historical accuracy, and he did not in fact succeed in satisfying them entirely. It was possibly due to a lingering memory of the bad reception of this painting at Court, as much as to his social deficiencies, that Turner owed the most conspicuous rebuff in his public life. Not only was Wilkie knighted by William IV, but his own inferior disciple Callcott was knighted by Queen Victoria. This invidious distinction was a slight he felt keenly.

103 *Trèves*, a page from the sketchbook used for a Moselle and Rhine visit, probably 1826

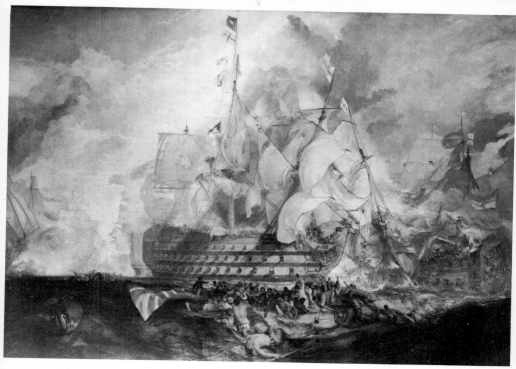

104 *The Battle of Trafalgar c.* 1823

Certainly in those years he was in a position to hear about the Court, for in 1827 he went to East Cowes Castle to stay with John Nash, then high in favour with the King, and turning from his works at Brighton Pavilion to the reconstruction of Buckingham Palace. Here Turner stayed a relatively long time, filling four sketchbooks with drawings of the yachts racing in *Ill. 106* the Solent, and local views. More unusually, he got his father to send two unstretched canvases, each sized three by four feet. On these he painted nine oil sketches from nature, of shipping at Cowes, the Regatta held in August and an interior of the mess deck of a man–of–war. These lively and spirited pieces *Ill. 105* supplied the materials from which he painted a pair of pictures shown at the Royal Academy in 1828: *East Cowes Castle, the seat of J. Nash, Esq; the Regatta beating to windward* and similarly,

105 *Between Decks* 1827

Ill. 107 *East Cowes Castle; the Regatta starting for their moorings.* The latter, which is in the Sheepshanks Collection in the Victoria and Albert Museum, is one of the most happily balanced of Turner's oils of the middle years. Perhaps as the result of the long, almost leisured period he had spent absorbing the atmosphere of this one place and its chief event, the keen eye, the sensitivity to atmosphere and the knowledge of shipping are all present, without the eccentricity which make the contemporary *Dieppe* and *Cologne* disconcerting. Once again the viewpoint is directly into the sun, which is reflected in the waters of the basin. This is one of the pictures which has suffered from an insufficiently prepared ground, and from the accretions of pigment giving extra brightness to the sun and its reflection, making a permanent tendency to flake. He put his experiences at Cowes into two other exhibits of 1828, the Carthaginian picture *Dido*

Ill. 108 *directing the equipment of the fleet* and *Boccaccio relating the tale of the birdcage,* in the manner of Stothard.

124

106 *Yacht racing in the Solent* (1) 1827

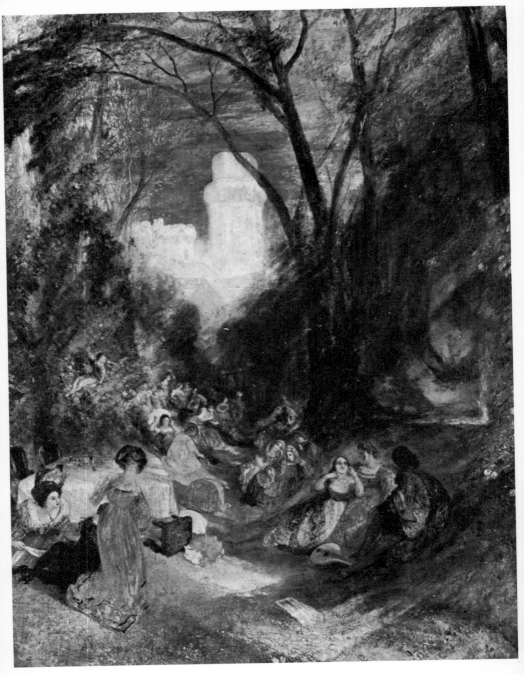

108 *Boccaccio relating the tale of the birdcage* 1828

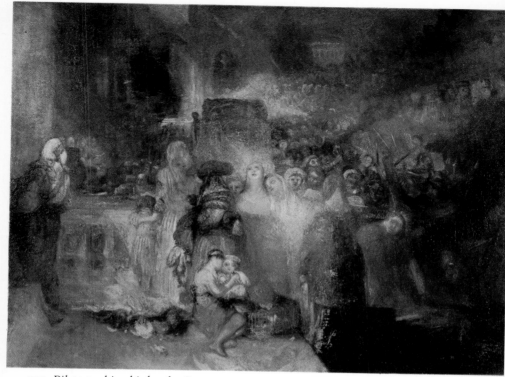

109 *Pilate washing his hands* 1830

There was yet another enlargement of his interests. In the Louvre in 1802 he had found, as we have seen, the Rembrandts 'miserably drawn and poor in expression', and shortly after had painted his *The unpaid bill, or the Dentist reproving his son's prodigality* as a comic pendant for Payne Knight's Rembrandt, *Candle Piece*. Now he was inclined to take Rembrandt seriously. In his lecture on landscape he remarked again on the objectionable nature of Rembrandt's forms but added 'over each he has thrown that veil of matchless colour, that lucid interval of morning dawn and dewy light on which the eye dwells so completely enthralled . . . as it were thinks it a sacrilege to pierce the mystic shell of colour in search of form'. With this to reinforce his growing concern with the role of colour in painting he exhibited in 1827 *Rembrandt's Daughter*, which was bought

127

Ill. 109

by Fawkes' son to add to the collection at Farnley Hall; and he returned to the same mode in 1830 with *Pilate washing his hands*.

In the nine years since he had been in Italy this variety of subjects and styles showed a ferment of ideas without one single issue. And he had also been busy for the engravers, including the imposing series of *Rivers of England* and *Picturesque Views in England and Wales*. In 1828 he began the watercolour vig-

Ill. 139

nettes for engraving in Rogers' poem *Italy*, the most successful of his illustrated books. Then, as though he could no longer be content with reading of these places he set out in August, once again on his way to Rome. This time it was his express intention to paint finished exhibition pictures. Accordingly he had a studio set up for him by Eastlake, to whom he wrote, 'Order me whatever may be necessary to have got ready, that you think right, and plenty of the useful, but nothing of the orna-

110 *Orvieto*, painted in Rome in 1828

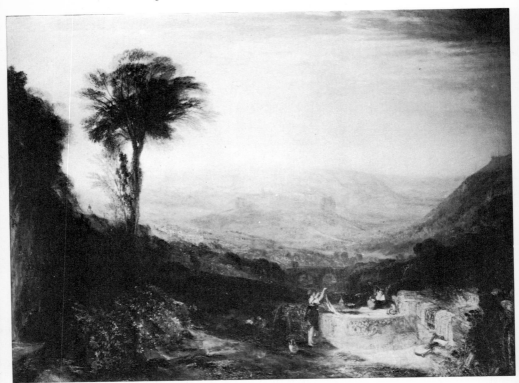

mental; never mind gimcracks of any kind.' In this character-
istic simplicity he intended to do his work, which was to include
painting a companion to Lord Egremont's Claude. He was two
months on the way and suffered badly from the heat, but
ultimately set up in the Piazza Mignanelli, in mid-October.

Here, as on the first visit to Italy, he was more in the public
eye, and more accessible than in London, and accordingly there
are some accounts of incidents in his life there. Eastlake, who
shared the same house, recorded his frugal method of framing
the canvas with painted rope. He also made the valuable
observation that Turner prepared his pictures with 'a kind of
tempera' and was therefore apprehensive of their being ruined
by contact with water before they had been varnished. In two
months he began eight or ten pictures and finished three which
he exhibited in his studio. Since the Nazarenes, with their
austere love of outline and cold colour, were still one of the
chief points of interest to the Roman public, this was a bold step,
and of the thousand visitors who came to see *Regulus, Orvieto,* *Ill. 110*
and *The Vision of Medea* many were critical. Others admired
his daring, but it does not seem that he acquired followers by
showing these works. Turner himself looked carefully at the
Sistine Chapel, and also at the work of the large group of
English sculptors in Rome, headed by Gibson. On the return
journey we have a delightful first-hand impression of him by
a fellow traveller:

I have fortunately met with a good-tempered, funny, little,
elderly man, who will probably be my travelling companion
throughout the journey. He is continually popping his head
out of window to sketch whatever strikes his fancy, and
became quite angry because the conductor would not wait
for him whilst he took a sunrise view of Macerata. 'Damn
the fellow!' says he. 'He has no feeling.' He speaks but a few
words of Italian, about as much of French, which two
languages he jumbles together most amusingly. His good
temper, however, carries him through all his trouble. I am

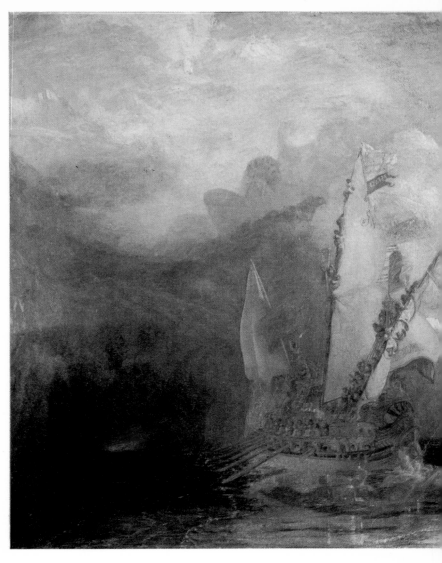

sure you would love him for his indefatigability in his
favourite pursuit. From his conversation he is evidently *near
kin to*, if not *absolutely*, an artist. Probably you may know
something of him. The name on his trunk is, J.W. or
J.M.W. Turner!

History repeated itself on his return by the Mont Cenis route in January 1829; his diligence again foundered in a snow-drift. And, while Constable had been made an A R A during Turner's previous absence in November 1819, Turner was present at the meeting at which Constable was elected R A in February

131

1829. The election was by only one vote, and the rumour was that Turner was not in favour of his rival's election. When canvassing unsuccessfully the year before Constable wrote to Leslie, 'I am sorry that Turner should have gone growling to Chantrey, but I recollect that I did not quite like the whites of his eyes and the shake of his head.' However, he went round to announce the result to Constable.

The experience he had set himself, of painting in the Roman light, was a further step in his increasing liberation from a tonal palette towards the freedom of colour of his later works. Since the actual pictures he had finished at Rome for the 1829 Exhibition had not arrived in time he worked hard on his return to finish an alternative group. *The Loretto necklace* has as its chief incident a peasant giving a necklace to a girl, and recalls by its landscape that it was at Loreto that Turner had recorded in 1819 seeing his 'first bit of Claude'. But a far more *Ill. 111* important work was *Ulysses deriding Polyphemus*, which is one of the outstanding paintings in his entire career. For the composition he went back to a drawing he had made about twenty years earlier. He seems also to have had some knowledge of Poussin's treatment of the subject, for the theme of Polyphemus stretched out on the top of a mountain crag is common to this work and to the Hermitage picture. But the staggering richness of colour shows that he has absorbed the lessons and reflections of his second visit to Rome. The decorative and baroque poop on which Ulysses is sailing resembles the vessel on which Etty had shown Cleopatra's arrival in Cilicia in 1821; the nymphs which attend it are an especially happy example of Turner's imagination playing on the classical story. But in an odd way it is Polyphemus who becomes the centre of action; he assumes the tragic posture of Prometheus and appears to be defying his tormentor Ulysses rather than being derided by him.

He had kept his room in Rome intending to return for a successive year, but decided not to go. The reason he gave Eastlake for not going early in the year was his dread of the excessive heat, but the real motive may have been anxiety

112 Oil sketch for *Ulysses deriding Polyphemus*

about his father's health. He had barely returned from a short visit to Paris and Normandy when his father died, in September 1829, at the age of eighty-five. This was a telling blow for Turner, after the years of intimacy which had gone before; he said he felt as though he had lost an only child. In the Academy elections for President which followed shortly afterwards, on the death of Lawrence, he was virtually not considered, and this was another source of discouragement. In these circumstances his more frequent visits to Petworth as the guest of Lord Egremont became a solace to him. Egremont, who in his capacity of patron of British art had bought his first painting by Turner in 1802 and had added a number since, now commissioned him to paint four large landscape panels in the Carved Chamber. The fact of being commissioned for such work was itself of importance to Turner, for he had failed to sell *Ulysses deriding Polyphemus* or any of his most ambitious pieces at recent

113 *Music party, Petworth c.* 1830–7

134

114 *Interior at Petworth c.* 1830–7

exhibitions. His sense of pleasure in the humane and cheerful atmosphere which Lord Egremont spread around him can be felt in the intimate series of sketches, mainly of interior scenes, which he now made at Petworth. In a large number of swift water- or body-colour drawings he noted down the details of life in the great house – four-poster beds with great canopies and rumpled sheets, the guests gathering for dinner, the picture gallery, the billiard-room, and himself painting watched by three women. He followed the same train of ideas in some oil sketches painted there, notably *Interior at Petworth*, in which a brilliant light dissolves the scene into its colour constituents and spills like the debris on the floor of the room. The informality of these sketches was a foil to the more formal landscapes he had

Ills. 115, 11

Ill. 114

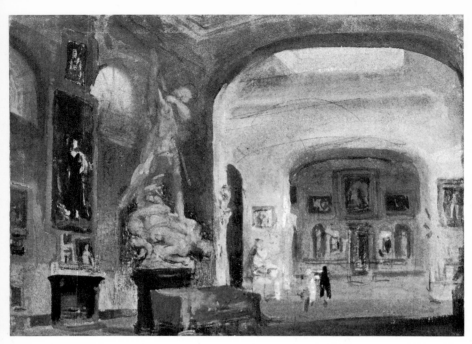

115 *The picture gallery, Petworth, with Flaxman's 'Satan overcome by St Michael' in the foreground c.* 1830

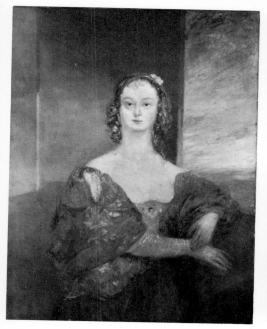

117 *Lady trying on a glove c.* 1830 118 *Jessica* 1830

undertaken, and for which he made sketches of the same size. But again the choice of a viewpoint looking directly into the sun enabled him to make of his subjects naturally composed, almost artless, compositions, distinguished in the case of *Petworth Park* and *The Lake, Petworth* by the long shadows cast by the animals, and in *Chichester Canal* by the serene reflections of boat and banks in the water. *Ill. 120*
Ill. 119

In Rome, Turner had painted *Palestrina* to act as a pendant to Lord Egremont's Claude; but his patron preferred to buy Turner's *Jessica* from the same Royal Academy Exhibition of 1830. This study of a girl in contemporary dress leaning from a window in the manner of a Dou is one of the evidences of Turner's increased interest in the 1830s in figure compositions. The *Woman reclining on a couch* (Tate Gallery, London), an unfinished work derived from the Hoppner *Venus, A sleeping* *Ill. 118*

Ill. 123

137

116 *Interior of a room at Petworth with a fireplace, blue and white china jars*

Nymph at Petworth, comes from this renewed attention, as does
the *Lady trying on a glove* painted in emulation of Lord Egre-
mont's Van Dyck portraits. Among the most ambitious was
the *Watteau study by Fresnoy's rules* which he showed at the
Royal Academy in 1831. Referring again to Watteau through
the medium of Stothard, as he had in *What you will!* and
Boccaccio relating the tale of the birdcage, this shows an artist
painting in front of his admirers, much as he had sketched
himself at Petworth. It is also an essay in the use of white as a

Ill. 117

Ill. 124

119 *Chichester Canal c.* 1830–1 121 *Landscape with water c.* 1835–40

120 *Petworth Park c.* 1830 122 *Norham Castle, sunrise c.* 1840–5

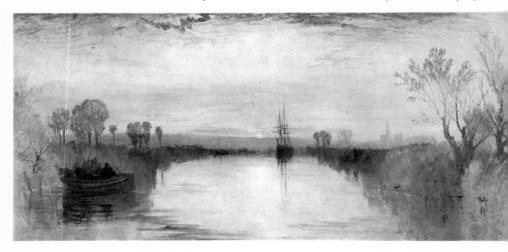

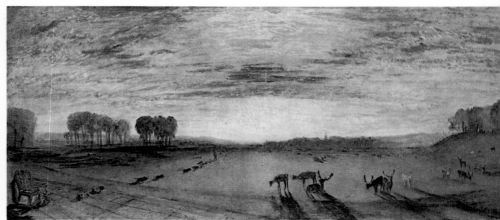

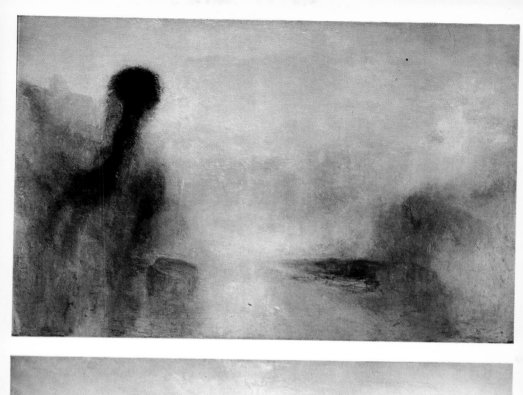

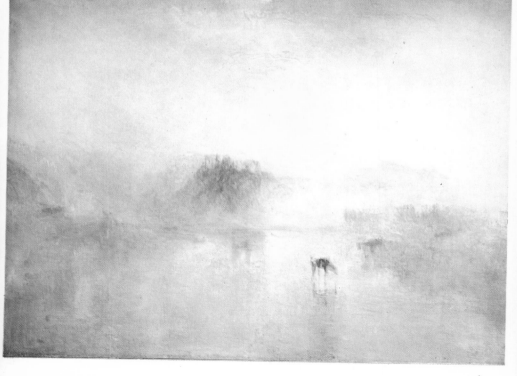

prominent foreground colour, a lesson reinforced by the quotation he printed in the catalogue entry:

White, when it shines with unstained lustre clear
May bear an object back or bring it near.

At the same exhibition he showed the seascape which he entitled *Life-boat and Manby apparatus going off to a stranded vessel making signal (blue lights) of distress* which he had painted for John Nash. When Nash died it appeared in his sale of 1835, and was bought, with *East Cowes Castle; the Regatta starting for their moorings*, by John Sheepshanks; it now hangs in the Victoria and Albert Museum as *Vessel in distress off Yarmouth*.

Ill. 125

The 'Manby apparatus' was an early application of the rocket to life-saving and was developed by Manby after he had witnessed a disastrous shipwreck when he was barrack master at Yarmouth. The painting is a remarkable instance of the painter's, and his patron's awareness of current events, for he exhibited it in the year 1831, when Manby was elected a Fellow of the Royal

123 *Woman reclining on a couch c.* 1830–1

124 *Watteau study by Fresnoy's rules* 1831

Society. That Sheepshanks bought it at a time when most of Turner's uncommissioned exhibits were coming back unsold from the Academy shows that the painting was not too extreme in its style to alienate a representative collector of modern paintings. The rocket with the life-line can just be seen against the dark sky, on its trajectory between the mortar, marked by a puff of smoke on the beach, and the vessel almost invisible in the stormy sea. These effects, and the trails of the distress signals from the ship, greatly appealed to Turner in his fondness for accents of light against mist and vapour.

The theme of *Watteau study by Fresnoy's rules* recalls a growing propensity of the artist in these years. Although he was notorious for secretiveness about his methods, Turner had by now established the tradition of working in full view of his fellow artists during the 'varnishing days' before the Summer Exhibition of the Academy. Most of the descriptions of these events come from the 1830s, and they all agree in emphasizing that his canvas to begin with was 'without form and void', and that it

Ill. 124

took on its appearance of completion during these three 'varnishing days'. Turner had a variety of motives in coming out of his shell for this annual display of his skill. One was to demonstrate that he could 'outwork and kill' any other artist. Certainly his physical stamina was remarkable, and was shown on these occasions, when he began before breakfast and worked while daylight lasted, as much as by his endurance of travel and the multiplicity of his productions.

The 'varnishing days' were times when he could keep an eye on his rivals and there are many stories of his deliberately setting out to paint his pictures in a higher key than the surrounding exhibits. A significant one concerns Constable's *Whitehall Stairs, or the opening of Waterloo Bridge*. With its robust treatment and its use of reds in contradistinction to his usual range of natural greens, it might be thought that Constable was here himself trying to outvie Turner's brilliance of effect. Turner

125 *Vessel in distress off Yarmouth* 1831

126 *The Evening star* 1830

had a grey seascape in the same room; at last he added 'a round
daub of red lead, somewhat bigger than a shilling, on his grey
sea'. As Leslie recalled the episode, 'the intensity of the red lead,
made more vivid by the coolness of his picture, caused even the
vermilion and lake of Constable to look weak'.

'He has been here,' said Constable, 'and fired a gun.' 'A coal
has bounced across the room from Jones's pictures,' said Cooper,
'and set fire to Turner's sea.' Then, in the last moments left for
painting he 'glazed the scarlet seal he had put on his picture,
and shaped it into a buoy'. While this shows his determination
not to be outshone, literally, by his rival, it also shows his
confidence in his power to pull his picture together at the last

minute. When working on *The burning of the Houses of Parliament* he was again watched, with amusement tinged with awe, while making a finished picture out of a mere beginning:

> In one part of the mysterious proceedings Turner, who worked almost entirely with his palette knife, was observed to be rolling and spreading a lump of half-transparent stuff over his picture, the size of a finger in length and thickness. As Callcott was looking on I ventured to say to him, 'What is that he is painting his picture with' to which enquiry it was replied, 'I should be sorry to be the man to ask him'. After it was finished Turner gathered up his tools, then, with his face still turned to the wall, and at the same distance from it went sidling off without speaking a word to anybody. At which Maclise remarked, 'There, that's masterly, he does not stop to look at his work, he *knows* it is done and he is off.'

Turner also valued these days as the main occasion when he and his fellow-artists could meet and work together, and when they could communicate the general tradition of British painting. Richard Redgrave comments on the value he found as a young Associate in this practice and gives as an example the help he received when he was being criticized for having exposed too much of the bosom of a female figure, 'Meanwhile, Turner looked over my shoulder, and, in his usual sententious manner, mumbled out, "What-r-doing?" I told him the rebuke I had just received from the secretary. "Pooh, pooh," said he, "paint it lower." I thought he was intent upon getting me into a scrape. "You want white", he added, and turned on his heel.' Puzzling out this advice, Redgrave realized that he meant him to paint a portion of the chemise over the top of the dress, in fact leaving the same exposure of flesh as before. This he did, and it passed the most prudish scrutiny.

Redgrave also comments on Turner's love of transferring a rich colour from other palettes to his own pictures, 'From our own palette he has whisked off, on more occasions than one, a luscious knot of orange vermilion or ultramarine, tempered

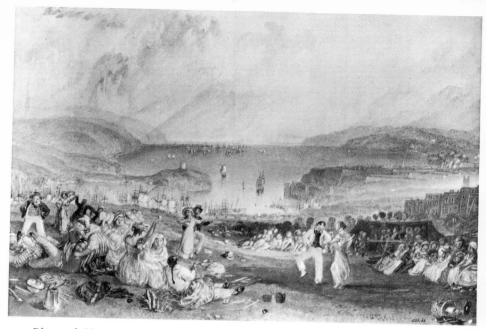

127 *Plymouth Hoe.* Engraved in *Picturesque Views in England and Wales* 1832

with copal, and at once used it on a picture he was at work upon with a mastic magylph.' As he points out, this mixture of media with differing drying qualities is a cause of failure in Turner's work, but is evidence of a wish to embellish the highlights and explains the fragmented, variegated texture of his exhibited pieces.

The same constant overall variation of colour, medium and form was by now well established in the watercolours he painted for public purposes, whether for exhibition, as models for engravers, or for direct sale to patrons. *Plymouth Hoe*, now in the Victoria and Albert Museum, is a representative example, with its reliance on every technical device known to Turner, its minute stippling, and the clumsy figures cavorting in the foreground. This was one of a long series prepared for engraving in the *Picturesque Views in England and Wales* series, and was exhibited with seventy-seven other watercolours at Messrs Moon, Boys, and Graves gallery in 1833.

Ill. 127

145

In complete contrast was the watercolour work he did in absolute privacy, in which he did not define the forms in a way recognizable to his contemporaries. With his fortunate mania for preserving all his work and keeping it together, these remarkable drawings have now come to the British Museum as part of the Turner Bequest. Finberg, when cataloguing the 20,000 or so drawings in the Bequest, could think of no better Ills. 128–31 description for them than 'Colour Beginnings'. There are related groups of boards stained with oil, and of beginnings on canvas, some in the British Museum, others in the Tate Gallery. Now that we have, through the development of modern art, become accustomed to purely chromatic, non-figurative canvases, it is possible to regard these remarkably harmonious, nearly abstract, designs as ends in themselves rather than beginnings. Whether Turner would have agreed remains in doubt. That he kept them at all shows that he valued them, and he can hardly have been unaware of the sort of completeness which we, over a hundred years later, can see in them. At the same time such canvases must have been of the kind he sent in to the Academy, prepared to work them up into the semblance of a picture recognizable for his contemporaries during the three 'varnishing days', and his watercolours were often started in the same way, on a stained ground.

The date at which he began to make these 'Colour Beginnings' is, like so much in Turner's private life, irrecoverable. Certainly he had begun the series in the 1820s, perhaps shortly after his first visit to Italy. A number of the oil sketches of similar type, several painted on one rolled canvas, have been *Ill. 132* assigned to his second Italian journey of 1828. They show a continuing and developing enquiry into the relationship between the three main ingredients of painting, form, light and colour. In his earlier work Turner defined form by following the classical precedents, and his range of colour was reduced accordingly. The independence of light and colour was demonstrated by Constable in one of his lectures when he held up a glass of water and said: 'Brightness was the characteristic

146

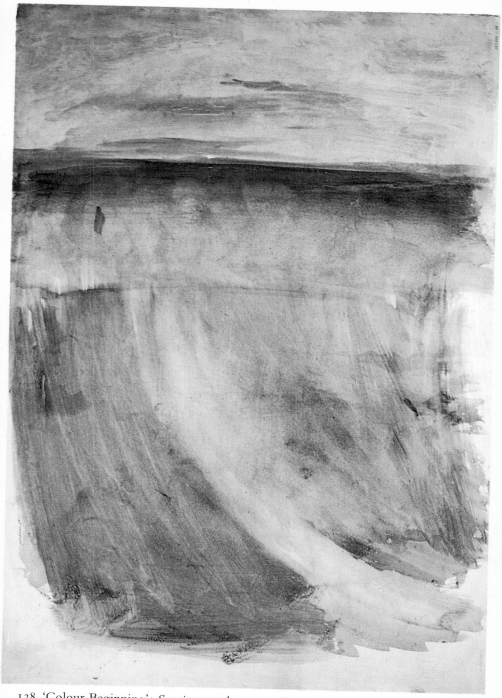

128 'Colour Beginning': *Sunrise over the waters*. Paper watermarked 1825

129 *Cartmel Sands*. On paper watermarked 1828

130 'Colour Beginning.' Some of the pigment has been flicked or thrown on

131 'Colour Beginning': *Oxford High Street*

excellence of Claude; brightness independent of colour, for what colour is there here?' While Turner had and retained a miraculous tact in the management of light throughout his pictures, the result of his reflections, his experience and his Italian journeys was to direct his interest towards the colour in the visible world, if need be at the expense of its form. His always present fascination for the immaterial vehicles of colour, steam, smoke, mist, helped him to make this choice. So in the later finished pictures he composes in colour, dissolving, suggesting, and only half-defining, form; in his private exercise he composed in coloured washes alone, virtually excluding any reference to the forms of nature, unless we regard them as veiled areas of sky, earth, and sea.

As with Hazlitt's criticism in 1816 that his paintings were 'of nothing and very like', a description which we think may be more reasonably applied to the later paintings, so some of the

149

132 *Lake Nemi c.* 1828–9

Ill. 147 criticisms made of Turner's public appearances in the 1820s and
1830s seem prophetic of these beginnings unknown to his
contemporaries. For instance, in 1836 when Turner exhibited
Juliet and her nurse, a Venetian subject, together with *Rome, from
Mount Aventine* and *Mercury and Argus*, Constable wrote,
'Turner has outdone himself, he seems to paint with tinted
steam, so evanescent and airy'. He might have been describing
the 'Colour Beginnings' which, of course, he had never seen,
rather than the exhibited pictures.

Yet more private were the sketchbooks in which Turner
made compositions of couples in bed, and other Priapic
subjects. It is one of the pleasanter ironies of history that Ruskin,
who was not conspicuous for matrimonial success, was obliged
to review these frankly lustful scenes amidst all the drawings in
the Turner Bequest. He inscribed one sketchbook of this kind
with the words, 'They are kept as evidence of the failure of
mind only.' But in them a number of important strands in

150

Turner's make-up come together; a perfectly normal enjoy-
ment of sex, his fascination with the interiors of rooms, the
whirlpool compositions which absorbed him and, in the later
examples, his exploration of the possibilities of figures dimly
visible in semi-darkness.

It seems to have been around 1833 that he first met Mrs
Booth, who was to play in his final years the role of the cosy
widow which Mrs Danby had occupied in his early manhood.
He had already, shortly after his father's death, begun making
the series of wills in which he staked his claim to the interest of
posterity. His main interests were to found a Professorship of
Landscape Painting at the Academy (a role he had tried to fulfil

133 *Coast scene near Naples c.* 1828

134 *A harbour with a town and fortress c.* 1835–40

in some of his lectures on perspective), to provide charity for decayed landscape painters, and to ensure that two of his paintings should hang in the National Gallery beside the works of Claude in competition against which they were painted. Later drafts extended the number of works he wished to be kept together as a bequest to the nation; at one time it was all his finished paintings, but this was extended to include all his paintings and sketches whatsoever. In the same mood he was now buying back key works which appeared on the market, *Ills. 52, 43* such as *The Sun rising through vapour* and *A country blacksmith disputing upon the price of iron,* from the sale of Lord de Tabley's (the former Sir John Leicester's) collection in 1827.

The tragic vision

Besides their value to him as commissions when he was selling few of his large paintings, the tasks Turner undertook with the illustration of books frequently enlarged his repertoire of subjects or suggested further developments in his work. When in 1821 the publisher Cadell suggested that he should be asked to make the drawings for the collected version of Scott's poems, Turner only grudgingly consented. Scott and Turner were fated not to be agreeable to one another; Scott had written in 1819, 'Turner's palm is as itchy as his fingers are ingenious and he will, take my word for it, do nothing without cash and anything for it. He is almost the only man of genius I ever knew who is sordid in these matters', but hoped none the less with the help of his drawings to sell 8,000 rather than 3,000 copies of his book. Turner made a fuss about going to Scotland at all, and apparently annoyed everybody at Abbotsford when he did get there. But after this was over he explored the West, and took the newly established steamer to Staffa. The weather was bad, and Turner barely got to Fingal's Cave by precariously scrambling over the rocks. From the slight outline memoranda he made at the time, reinforced by his memory of the event, he constructed *Staffa. Fingal's Cave* which he exhibited at the *Ill. 135* Royal Academy in 1832 and which has rightly become known as one of the most perfect expressions of his romanticism. He himself described the experience out of which it arose: 'The sun getting towards the horizon, burst through the rain-cloud, angry, and for wind.' This was the first painting by Turner to go to the United States. After it remained unsold for thirteen years, C. R. Leslie chose it for James Lenox, whose first reaction was disappointment at its indistinctness. When Turner heard

135 *Staffa. Fingal's Cave* 1832

136 Vignette to Rogers' *Poems* 1834

this he made the famous reply: 'You should tell him that indistinctness is my *forte.*'

A whole group of illustrations to other poets were required of Turner at about the same time as the Scott drawings. The most famous, and perhaps the most successful, were the two volumes he decorated for Rogers, the *Italy* of 1830 and the

Ills. 136–40 *Poems* of 1834. He made designs for Byron's poems in an edition published by Murray in 1834, and accepted a commission to provide vignettes for Campbell's collected poems, the edition being produced in 1837. Campbell's text had a special significance for him, since he had been for years an admirer of the *Pleasures of Hope*, and had framed his own *Fallacies of Hope* as a commentary upon its optimism. Not that Campbell himself is a blind optimist; his works are full of

156

139 *Villa Madama:
moonlight*. Engraving
for Rogers' *Italy* 1830

137 *The evil spirit*.
Vignette to Rogers'
Poems 1834

138 *The Phantom Ship*.
Engraving for *The
Voyage of Columbus*,
Rogers' *Poems* 1834

realistic descriptions of disaster, and he felt sympathy with ship-wrecked sailors and slaves no less than with a conquered country such as Poland. His honesty of vision, combined with the robust patriotism of *Ye Mariners of England*, was similar to Turner's own make-up, and the two men shared the passion for liberty and awareness of sacrifice fostered by the Napoleonic wars.

In the group of illustrations as a whole Turner took endless pains in the control of his engravers, who were working on the harder but more durable metal, steel: he succeeded in evoking a remarkable fidelity to the rendering in black-and-white of his subtle nuances and minute variations in tone. By adopting the vignette form with its irregular outline and hence looser mode of composition, he liberated his imagination and was able to render with a teeming fantasy the episodes described in the poems he illustrated, whether they were the vision of Columbus

Ill. 138 seeing the ghostly army in Rogers' *The Voyage of Columbus* or
Ill. 140 the destructive fighting recalled in Campbell's *Hohenlinden*. It was in this way, and on this small scale, that he evolved formal ideas which he worked out more ambitiously in the oils of his
Ill. 172 last years, such as *The Angel standing in the sun* and the two paint-
Ills. 161, 163 ings based on Goethe's theory of colour.

While the engravings spread his fame on the Continent, he was no more successful in creating a taste for his oil paintings out of England than he had been when he actually showed his work in Rome. In 1824, the year in which he became a founda-tion member of the Athenaeum, he was not amongst the English artists who made such a stir by their exhibits at the Paris Salon. Lawrence, Constable, and Copley Fielding were represented, and Bonington also was amongst those who were awarded a gold medal. Four years later Bonington's brilliant career was over. Only in the last three years of his life had he shown in England, at the British Institution and the Royal Academy. While Constable was affronted by his, to him, superficial precocity, Turner was responsive. Amongst the exhibits were Venetian subjects – the *Piazzetta*, *The Ducal Palace*, the *Grand Canal with the Salute* – painted with the fresh

140 *Hohenlinden*. Engraving for Campbell's *Poems* (enlarged)

colour and the bravura of which Bonington was a master. These luminous paintings were probably the main incentive for Turner's renewed desire to return to Italy, and for the sudden profusion of Venetian themes in his own painting.

It has generally been accepted on the faith of Finberg's dating of the sketchbooks that Turner did not visit Venice between 1819 and 1835. But unpublished notes by the late C. F. Bell give plausible reasons, based on the changing amounts of scaffolding round the Campanile, for supposing that he made a slightly earlier return, probably in 1832. The desire to see parts of Germany and Austria for his work on Campbell's *Poems* may have been a contributory motive, while in Rogers and in Byron he came across many references which must have urged him to return to Italy and in particular to Venice. One of his exhibits at the Academy Exhibition of 1832 was *Childe Harold's pilgrimage – Italy*. He accompanied the catalogue entry for this with lines quoted from memory out of the Fourth Canto of Byron's poem; significantly they describe the present decay as well as the present beauty of Italy:

> *Thy very weeds are beautiful . . .*
> *Thy wreck a glory.*

The Exhibition of 1832 was notable for the attempt by Turner to paint down Constable's *Whitehall Stairs* in the manner already described. It was also marked by a more friendly piece of rivalry with George Jones, an artist who venerated Turner and remained on good terms with him. Before the Exhibition Turner asked him which subject he had chosen. Hearing that it was the deliverance of Shadrach, Meshach and Abednego from the fiery furnace, he was struck by its suitability for his own style with its theme of glowing flames and, with Jones' agreement painted his version of the theme.

Ill. 141 Then, and if Bell is correct, after a second visit to the city, he exhibited in 1833 two Venetian scenes. Although he had visited Venice as long ago as 1819, these were the first important renderings he made of a theme which was to obsess him for the

141 *Bridge of Sighs, Ducal Palace and Custom-House, Venice: Canaletto Painting* 1833

next fourteen years, taking the place occupied by scenes depicting Carthage in his earlier phase. From now on he introduces his full perception of atmosphere and light into the paintings of Venice. He had prepared the ground by an extensive series of topographical drawings he made from the time of his first visit, and the city is both a real place and a quarry out of which he could extract the materials for his fantasy.

In the next year, 1834, he showed another painting of Venice, and with it *The golden bough* in which he once again *Ill. 144* fitted the Bay of Baiae into the Claudean scheme, and found an apt poetical illustration of the legend which gave men power to return from the underworld. A story is told which shows his experimental methods of working: the figure of the Sibyl in the foreground was a page cut from his sketchbook and pasted on the canvas. This he replaced a few years later.

A sensational event had occurred in London, the deep effect of which on Turner can be seen in his sketches and paintings.

142 *The Burning of the Houses of Lords and Commons, October 16, 1834.*
Exhibited R A 1835

This was the destruction by fire on 16 October 1834 of the old Houses of Parliament. Turner was there and, uninhibited by his usual fear of being watched while sketching, made a number of hasty watercolour sketches of the brilliant scene. The special significance of the sight for him arose in part from the fact that it was an historic building on the Thames a very short distance away from his birthplace. It had been a solid and venerable monument of his early childhood memories, and had attracted an important part of the feelings of personal possessiveness which he had for all the features within his ken on the river's course. Here Turner's fascination with brightness and colour, seen at their most spectacular in a vast fire at night, could have full play. He translated his brilliant, almost instantaneous water-colour sketches (so hastily made that he blotted one page of his sketchbook on another) into two oil paintings of the subject. The earlier to be shown, at the British Institution, and now in

143 *Keelmen heaving in coals by night* 1835

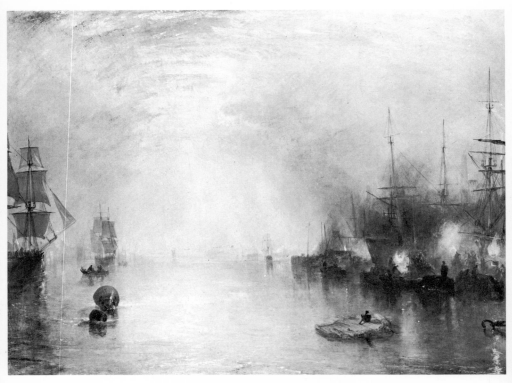

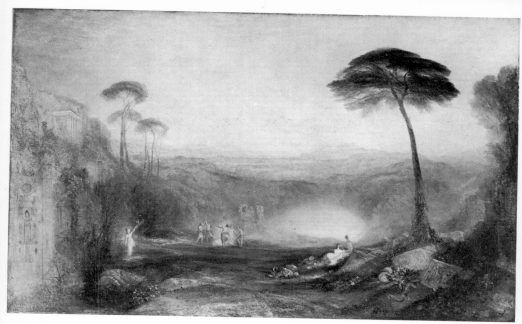

144 *The golden bough* 1834

Philadelphia, treated the subject from the south end of West-minster Bridge. Then he showed at the Royal Academy a second rendering (now in the Cleveland Museum of Art) giving a long-range view down the river, with the great arc of flame, in the more incandescent yellows and oranges sweeping across the night sky. The real fire of a building close to his heart has replaced the feigned Egyptian fires of *The fifth plague of Egypt.* From now on he was more and more liberated in his attitude to colour of the highest pitch. At the same Academy exhibition he showed *Keelmen heaving in coals by night*, now in the National Gallery of Art, Washington, an industrial scene on the Tyne in which a good deal of the mysterious interest comes from the flares which light the night-time operation. This is a river-piece amalgamated with Turner's interest in the lights and grime of a commercial port, such also as he had grown up with in London.

Ill. 142

Ill. 143

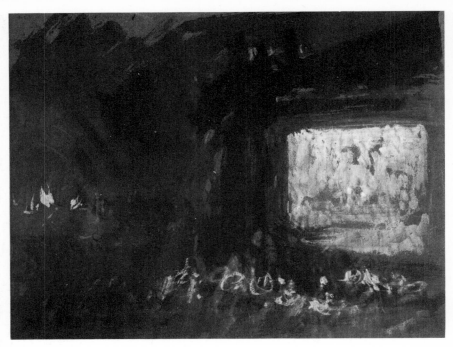

145 *Open air theatre, Venice* 1835

146 *Figures on a bridge, Venice* 1835

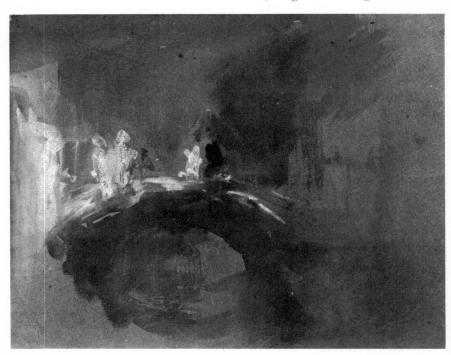

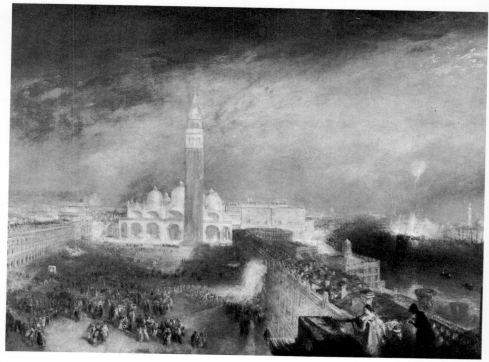

147 *Juliet and her nurse* 1836

When he went to Venice bright meteoric lights were still in his mind. Pages in which dimly discerned interior scenes – a murder, a wineshop, his bedroom – emerge from the dark paper are a special point in the sketchbooks he used on this visit of 1835. In the same book he sketched the great buildings at night with emphatic lighting – a storm with lightning in the Piazzetta, and fireworks and Bengal lights luridly illuminating the Salute. Venice was *en fête* at the time and those fireworks entered into his next Venetian picture – the *Juliet and her nurse* shown at the Royal Academy in 1836. The ambition of this treatment of the subject shows how far he had been spurred on by the illustrations to the poets which he had undertaken in the 1830s. Using his own artistic licence to transport Juliet from

Ills. 145, 146

Ill. 147

Verona to Venice, he shows her and her nurse looking down from the rooftops on a lively carnival scene in the Piazza di San Marco. The night is lit by fireworks, and Turner has expressed his feeling for the gaiety of the scene by dissolving the forms in a shimmering atmosphere. The high viewpoint, and the row of buildings jutting into the centre of the picture, carry on a type of composition which he had been trying out in the vignettes for the poems of Rogers and Campbell.

The Venice paintings were in general more popular than much of Turner's other productions, and *Juliet and her nurse* was bought from the 1836 Exhibition of the Royal Academy with his other Italian picture *Rome from Mount Aventine* by one of Turner's more recent patrons, Munro of Novar. But it was the subject of a bitter attack in *Blackwood's Magazine*, written by the Rev. John Eagles. Eagles, a member of a well-to-do Bristol family, was that most dangerous of all critics, a disappointed artist who could write fluently. He had intended to be a landscape painter in the manner of Gaspard Poussin, but failed to gain admission to the old Water-Colour Society in 1809. This decided him to take orders, and he combined his clerical duties with much sketching and with writing art criticism for *Blackwood's* from 1831. He was equally virulent about Constable and Turner, and with a fine consistency was attacking Millais' *Order of Release* in 1853. His standing was thus similar in some ways to that formerly occupied by Sir George Beaumont. But his dismissal of *Juliet and her nurse* as 'thrown higgledy-piggledy together, streaked blue and pink, and thrown into a flour tub' aroused the indignation of Ruskin, who was then seventeen and whose interest in Turner had first been aroused by the present of a copy of Rogers' *Italy* with the vignettes. He composed a reply, which his father decided should be submitted to Turner before it was sent to the magazine for publication. Turner characteristically advised against noticing hostile attacks, 'I never move in these matters', and sent the manuscript to Munro of Novar to keep with the picture itself. This was the first step in the series of events which led to the

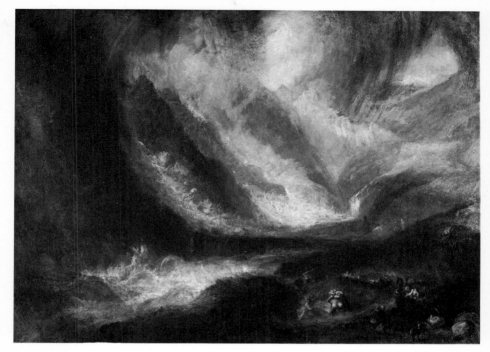

148 *Snowstorm, avalanche, and inundation* 1837

meeting between Ruskin and Turner in 1840 and the writing of *Modern Painters* as a more sustained defence of the later work.

As though he was determined to show his virtuosity, his exhibits in 1837 covered much of his range of styles and subjects. The *Scene – a street in Venice* now in the Huntington Art Gallery, carries on the idea of *Juliet and her nurse* by amalgamating a view of the Grand Canal, towards the Rialto, with an episode from Shakespeare, in this case the encounter between Antonio and Shylock, as well as a subsidiary episode involving the Friar. Again there is a foreground structure jutting into the picture space, but the scene is a daytime one lit by meridian light. *Apollo and Daphne* evoked his Claudean mood of calm, while *Snowstorm, avalanche, and inundation*, now in Chicago, is one of his most turbulent pictures of destruction, based on the swirling vortical curves which such apocalyptic concepts drew from him. *Ill. 148*

169

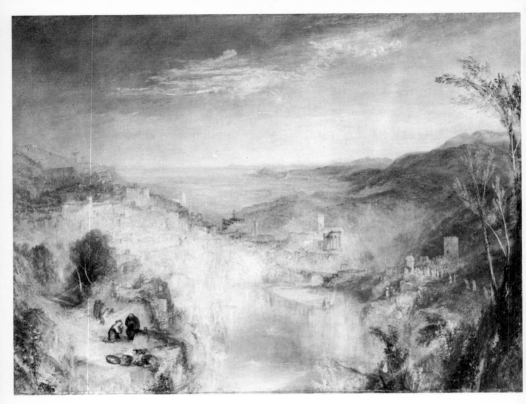

149 *Modern Italy: the Pifferari* 1838

Ill. 152

The third exhibit at the Academy was *The parting of Hero and Leander*. Subtitled 'from the Greek of Musaeus', Turner added verses of his own to define the exact moment of the lover's parting which preceded the disaster, emphasizing the early morning, the moon in the lingering night sky, which is of course heavy with the approaching storm, and the 'torch and failing lamp / The token of departure'. In this picture Turner takes up a classical theme in the true manner of the history

Ill. 111

painter and in succession to his *Ulysses deriding Polyphemus*. The great difference in treatment between this and his other exhibits seems partly due to the fact that he had planned such a picture many years before, in the sketchbook he had used on his first

170

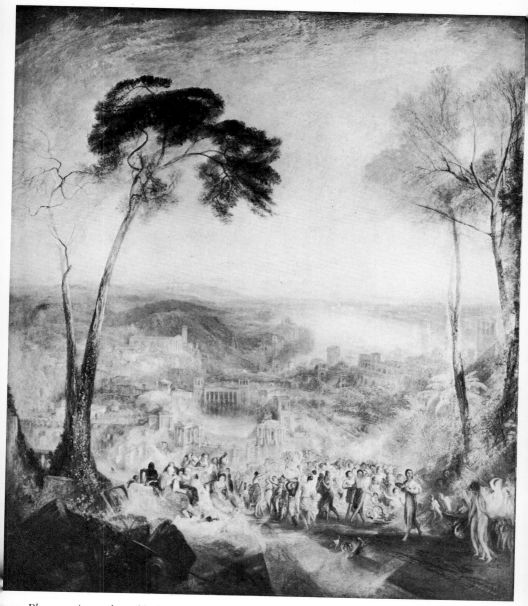

150 *Phryne going to the public bath as Venus: Demosthenes taunted by Aeschines* 1838

151 Sketch for *The parting of Hero and Leander c.* 1800–5

visit to France in 1802. The ranges of classical architecture
climbing up the hill to the left echo this early phase of his
devotion to Poussin, and the classical decorum of the whole
echoes the epic nature of the myth; even the sea-nymphs on the
right are an acceptable allegorical allusion. But to the more
composed arrangement of his earlier style for historical painting
Turner has added the richness and variety of colouring which
had been evident in his more recent work, continuing this with
his favourite contrast of warm colours, on the left hand, and
cold colours on the right, symbolic of disaster.

The impetus to take up this early idea and fashion it into one
of his most mature compositions may have come from Etty's
Parting of Hero and Leander which had been shown at the
Academy in 1827 and again in a loan exhibition at York in 1836.
Though this is a circular composition, with the figures far more

172

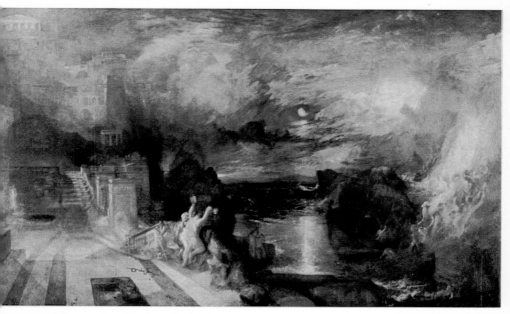

152 *The parting of Hero and Leander* 1837

prominent, there are striking similarities in their posture on the steps and in the moon shining through stormy clouds and reflected in the sea.

Constable died just before the 1837 Exhibition and was posthumously represented by his *Arundel Mill and Castle.* By some chance enthusiasts for Turner have rarely had much sympathy for Constable – Ruskin is the prime example – and the reverse is equally true. This has been unfortunate, for it has precluded the drawing of a most instructive contrast between two contemporaries equally eminent in the same field of land-scape painting yet diametrically opposite in temperament and the characteristics of their art. Comparison draws attention to those aspects in which the artists differ in the strength of their approach, and is an aid to the deeper appreciation of either. There is for example the devotion of Constable to his birthplace

and the *genius loci* in complete contrast to Turner's incessant travelling and ability to make almost any scene the subject of his art. Only in some of his Thames-side views, and latterly in his pictures of Venice, does Turner show any sign of such a devotion to the spirit of specific places. Their approach to the canvas is also different; Constable always concerned with the structure of his landscape in depth, while Turner comes more and more to dissolve depth in the play of colour over his surfaces. Constable's own description of paintings by Turner shows that he was fully aware of this distinction: 'he seems to paint with tinted steam, so evanescent and airy'. The few cloud studies which Turner made are often compared with those by Constable as though they were of the same time and carried out for the same purpose. But the distinction just made applies here, too. Turner is more concerned to note the colour nuances in veils of vapour than to emphasize the depth in the sky through which the clouds stretch. Constable is concerned with the clouds as almost sculptural three-dimensional entities. With Constable the sense of movement is attributed to the clouds as bodies; with Turner to the fine shades of tone and colour he notices with his incredibly sharp eye.

While Constable confined himself to a narrow range of subject-matter, and hardly attempted illustrative or historical painting, Turner, almost in defiance of the fact that it was a dying taste, liked to paint allegorical, mythological and poetical scenes. The differences in their characters were just as sharply defined: Constable was uxorious and devoted to children, Turner as far as possible free from personal ties; Constable highly articulate, Turner almost unable to express himself.

A good deal is known of Constable's relations with many lesser artists of his time; tantalizingly little of his relations with Turner. The episodes already recorded indicate a sense of mutual respect not unnaturally sharpened by a keen sense of rivalry and, at least on Constable's part, some jealousy. He once referred to Turner 'who would be lord of all'. In spite of all the pains he took to emulate the work of his contemporaries –

Wilkie, Etty, Jones, Martin, Bonington – Turner never seems to have tried to paint a version of English pastoral in direct competition with Constable. Possibly the more accented and less naturalistic colouring of Constable's last manner indicates a desire on his part to vie with Turner's increasing brightness of palette, and this could account for the riposte made at the hanging of *Waterloo Stairs* in 1832, when 'a coal bounced across the room . . . and set fire to Turner's sea'.

If Crabb Robinson is to be believed, Constable was gaining favour in the 1820s at the expense of Turner's supposed extravagances. However that may be, Constable's death left Turner without a visible rival of the same stature. In the summer of 1837 Queen Victoria succeeded to the throne, and her first honours list included Newton, the miniaturist, Westmacott, the sculptor, and Callcott, Turner's disciple, but not Turner himself: of this C. R. Leslie says, no doubt an understatement, 'I think it possible he was hurt.'

Turner's patron and friend Lord Egremont died in November 1837. He himself was ill, and felt obliged at last to resign the Professorship of Perspective at the Royal Academy. He had delivered his lectures only twelve times in the thirty-one years he held office, but had obstinately clung to the title. After formally thanking him his colleagues elected J. P. Knight as his successor and passed a resolution to prevent such neglect of duty.

By now he had an established pattern for the subjects he might choose to paint for exhibitions. His mind would turn to an interpretation of Italian scenery on Claudean lines, but transformed by his own colour sense. He would work out an epic embodiment of a myth or theme from ancient history, such as *Ulysses deriding Polyphemus* or *The parting of Hero and Leander*. To these he might add an apocalyptic scene of the destructiveness of natural forces, based on his own experience of the elements. With such widely differing types of subject and treatment he might very well combine a sea-piece, dealt with in a manner more akin to his darker, earlier style and therefore more acceptable to his contemporaries. In his later years literal

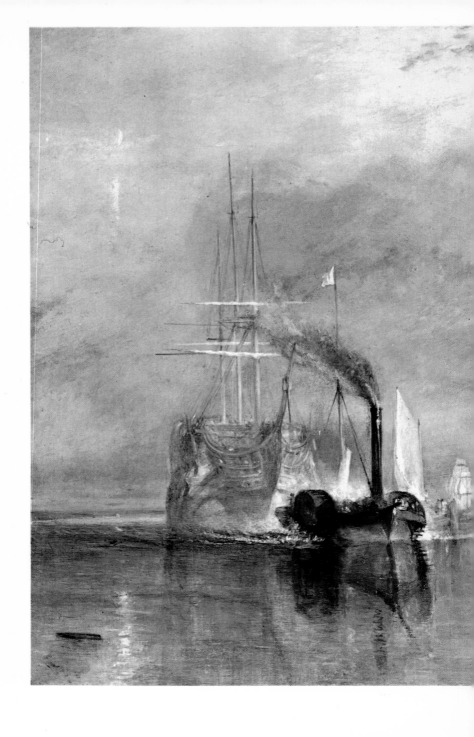

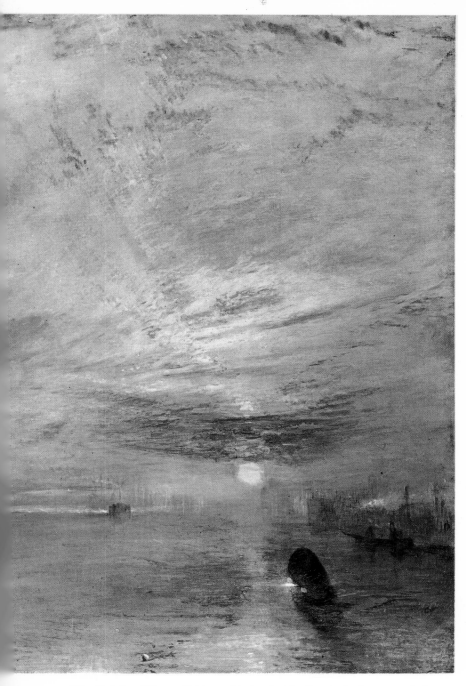

153 *The Fighting 'Temeraire' tugged to her last berth to be broken up, 1838*

topography was mainly confined to his watercolours, including serial views of river scenery such as the Rhine or the Loire. But the oil paintings of Venice have a topographical aspect about them, though it is often modified by the introduction of a narrative element such as that in *Juliet and her nurse*. Then there are the figure subjects suggested by his study of Rembrandt, Van Dyck, or Stothard. There is an evident parallel between most of these clearly defined types into which Turner's practice fell at the end of his life and that logical division into categories attempted in the original programme for the *Liber Studiorum*. What is most remarkable is the facility with which Turner turned from one mode of expression to another without losing his confidence and without submerging a sense of personal style in eclecticism. Nor did this variety of creative ability diminish his activity as a sketcher from nature, or the boldness with which he made his private investigations into the pure structure of his 'Colour Beginnings'.

Ill. 147

Italian subjects preponderated in his Academy exhibits of 1838 and 1839, but it was in one of his sea-pieces, *The Fighting 'Temeraire' tugged to her last berth to be broken up, 1838*, that he struck a new note. Here patriotism, feeling for the sea, and the impact of a great passing are fused with the intensity of his emotion. The *Temeraire* was a British-built ship, inheriting her French name from a prize captured at Lagos Bay, which had fought gallantly at Trafalgar. Turner had already portrayed the ship, seen over the shattered stern of the *Victory*, in his painting of *The Battle of Trafalgar*, and had seen her on the Thames being towed to Rotherhithe to be broken up. He produces his emotional effect as much by the symbolism of the glorious sunset lighting the ship for the last time as by the contrast between her white walls and the dark tug and buoy which she approaches, to be anchored for the last time.

Ill. 153

Ill. 46

The elegiac valedictory sentiment of this work was not carried into the sea-pieces he exhibited in 1840. The blood-red sunset has extended over a larger area of the sky in *Slavers throwing overboard the dead and dying – Typhoon coming on*. Turner

Ill. 154

178

said that he had been idle all the summer of 1839 and, given his keen appetite for all that was going on he may well, during that idleness, have read T. Clarkson's *History of the Abolition of the Slave Trade*, the second edition of which came out in that year. He seems certainly to have known the terrible story of the slave-ship *Zong* recounted there. As an epidemic was raging aboard, the Captain ordered the sick and dying to be thrown into the sea. He could claim insurance for them if they were lost at sea, not if they died on his ship. A storm, which would have relieved the shortage of water he pleaded in excuse, was coming up, and this linked the subject in Turner's mind with a passage from Thomson's *Summer* in which the wreck of a slaver in a typhoon is described. For the catalogue entry he used some lines of his own, in which he makes the oncoming typhoon the reason for the inhumanity, and suggests that the trader will lose his market – another example of the fallacies of hope. There is no more majestic or terrifying instance of the wind and sea as elemental and destructive powers in all Turner's work. The red of the sunset reflected in the stormy waves becomes merged with and synthetized into the blood of the victims, and the ship itself, silhouetted against the storm, acquires something of the mythical quality of the ghost ships which haunt maritime imaginations.

The idea of danger at sea, never far from his mind, comes out as clearly in his other major exhibits of 1840, which he called in full *Rockets and blue lights (close at hand) to warn steam-boats of shoal water* (now in the Clark Institute, Williamstown). *Ill. 155* Reminiscent in subject of the scene off Yarmouth he painted for John Nash nine years before, there is a wild extravagance in the shapes of the forms of which the picture is composed, the crests of the waves and the area of smoke and lights dis-torted by the wind. True to his intention of diversifying his exhibits he showed at the same time a *Bacchus and Ariadne* with derivations from Titian, a calm seashore scene *The new moon*, and two scenes of Venice. One of these, *Venice from the Canale* *Ill. 158* *della Giudecca*, was bought by Sheepshanks and is now in the

154 *Slavers throwing overboard the dead and dying – Typhoon coming on* 1840

Victoria and Albert Museum, one of the best preserved of these light-keyed city scenes.

That summer Ruskin met Turner for the first time, and recorded in his diary the same evening:

> Everybody had described him to me as boorish, unintellectual, vulgar. This I knew to be impossible. I found in him a somewhat eccentric, keen-mannered, matter-of-fact, English-minded gentleman: good-natured evidently, bad-tempered evidently, hating humbug of all sorts, shrewd, perhaps a little selfish, highly intellectual, the powers of his mind not brought out with any delight in their manifestation, or intention of display, but flashing out occasionally in a word or a look.

This tallies well with G. D. Leslie's description of his appearance in the last years of his life: 'He always had the indescribable

155 *Rockets and blue lights (close at hand) to warn steam-boats of shoal water* 1840

charm of the sailor both in appearance and manners; his large grey eyes were those of man long accustomed to looking straight at the face of nature through fair and foul weather alike.'

Although he was now sixty-five, he had another five years of arduous and adventurous travelling before him. These trips included his last visit to Venice in 1840, and visits to Switzerland in the four subsequent years. On his return from Venice his sense of occasion took him out of his way to visit Rosenau, the birthplace of Prince Albert, who had recently married Queen Victoria. This formed the subject of one of his exhibits at the Royal Academy in 1841; but if it was a bid for Royal patronage, it was not successful. A critic described it as 'eggs and spinach', and Prince Albert did not buy this or any other work by Turner for his collection. This was a portent of the increasing trend towards a more German taste in the 1840s, typified by the success of Dyce's paintings. Turner had come into contact,

156 *Rough sea with wreckage c.* 1830–2

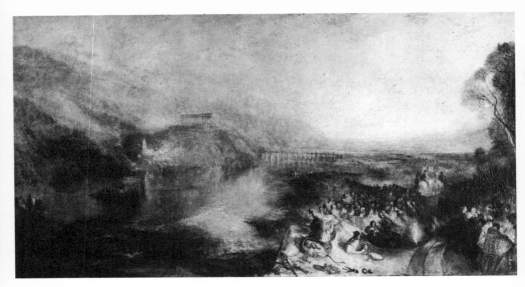

157 *The Opening of the Walhalla, 1842: Honour to the King of Bavaria* 1843

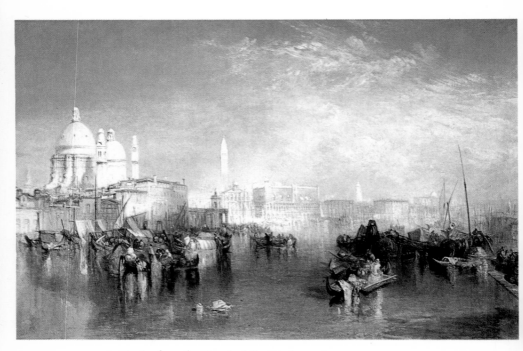

158 *Venice from the Canale della Giudecca* 1840

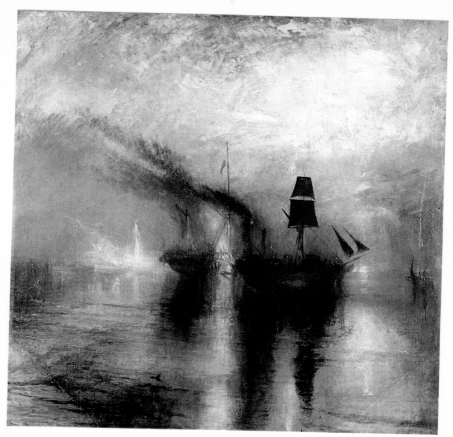

159 *Peace – burial at sea* 1842

no doubt, with the Nazarenes when he was working in Rome, so the sources of the new style were known to him. But now his natural competitiveness was in abeyance, and he made no attempt to emulate these new rivals.

On the same journey home from Venice he had sketched the Walhalla being erected near Regensburg by the King of Bavaria. This was a temple in the Grecian style designed by Ludwig I as a shrine of the arts. From his sketches Turner made the painting he entitled *The Opening of the Walhalla, 1842:* *Ill. 157* *Honour to the King of Bavaria,* which he then exhibited at the

Royal Academy in 1843. Two years later he sent it to a loan exhibition in Munich, where it completely failed to attract any understanding. On its return it was one of the paintings which most caught the attention of visitors to Turner's own gallery in Queen Ann Street. One of them was Elizabeth Rigby – later Lady Eastlake – who recorded:

> The old gentleman was great fun: his splendid picture of Walhalla had been sent to Munich, there ridiculed as might be expected, and returned to him with £7 to pay, and sundry spots upon it: on these Turner laid his odd misshapen thumb in a pathetic way. Mr Munro (of Novar) suggested they would rub out, and I offered my cambric handkerchief; but the old man edged us away, and stood before his picture like a hen in a fury.

Ill. 158

His production of Venetian pictures continued unabated; there were three at the Academy in 1841 and two in 1842. These were better received than his works on other themes and all five were sold. It was now that he revived an idea he had long contemplated of issuing five large and important plates of his picture, at his own risk. The plan was based on his admiration for Woollett's large engravings of Richard Wilson's landscapes. What makes the project of particular interest is the choice he made among his own works of compositions which, in his own words, 'would perhaps form another epoch in the English school'. They were *Mercury and Herse* (1811), *Dido and Aeneas*

Ill. 72
Ill. 147

(1814), *Crossing the brook* (1815), *Caligula's Palace and bridge* (1831) and *Juliet and her nurse* (1836). This short list, compiled when he could review the peak part of his career in retrospect, is, with one exception, linked to the Mediterranean. It includes his first Carthaginian picture, a mythological and a Roman scene, one of his most anecdotal Venetian pictures, and to these Italian themes he added the one English landscape which has always summed up this aspect of his work. The selection shows what weight he placed on the most ambitious kind of historical landscape painting which it had been so long his desire to foster.

186

The year 1842 was an imposing one for him at the Exhibition, and the origin of his two most familiar pictures there is known in some detail. *Peace – burial at sea* was his moving tribute to David Wilkie. Always acutely sensitive to the deaths of his associates, he had become increasingly lonely. His father's death in 1829 had been followed by the deaths of W. F. Wells in 1836, Lord Egremont in 1837, and Chantrey in 1841, shortly after Wilkie's death at sea on his return from the Near East. He commemorated his friend and rival after he had discussed the matter with George Jones, who planned a drawing of the committal of the body, taking the ship's deck as his viewpoint. To this Turner replied, 'I will do it as it must have appeared off the coast.' The mysterious finality of the action is developed by the heart of light in the centre of the picture, where the coffin is being lowered to the deep, and the contrast between this brilliance and the funereal blackness of the ship's silhouettes. The calm of the evening and the lightness of the breeze which hardly stirs the smoke emphasize the serenity implicit in Turner's title. When Stanfield told him the sails were too black he replied, 'I only wish I had any colour to make them blacker.' The picture really takes it place beside *The Fighting 'Temeraire'*, with a human loss replacing that of the ship itself: but when showing it Turner balanced the theme with a painting of Napoleon in exile meditating on the fatuity of his campaigns. This he called *War: The exile and the rock limpet* and expanded the title by one of his most successful excerpts from *Fallacies of Hope*. Napoleon is supposed to be meditating about the limpet:

Ill. 159

Ill. 153

Ill. 164

> *Ah! thy tent-formed shell is like*
> *A soldier's nightly bivouac, alone*
> *Amidst a sea of blood –*
> *– but you can join your comrades.*

The scheme devised for this picture enabled Turner again to make the metaphoric equation between red pigment and blood of which he was so conscious.

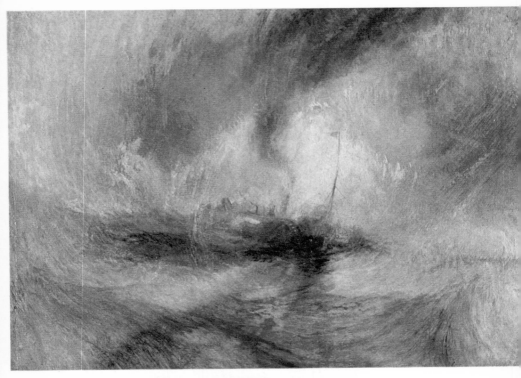

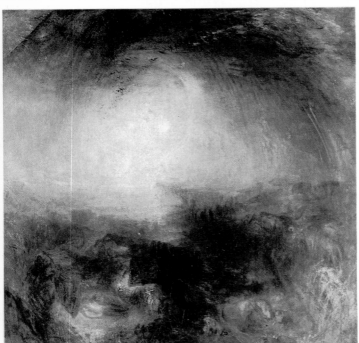

160 *Snowstorm –
steam-boat off a
harbour's mouth
making signals in
shallow water, and
going by the lead* 1842

161 *Shade and
darkness – the evening
of the Deluge* 1843

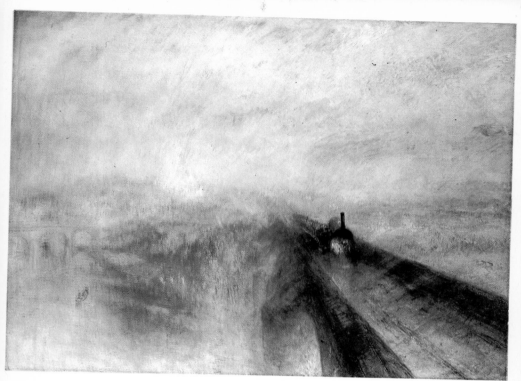

162 *Rain, Steam and Speed – The Great Western Railway* 1844

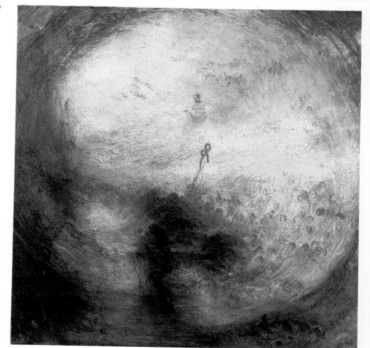

163 *Light and colour (Goethe's Theory) – the morning after the Deluge* 1843

Ill. 160 *Snowstorm – steam-boat off a harbour's mouth making signals in shallow water, and going by the lead* has the impact of total immediacy about it. As he completed the title, 'the author was in this storm on the night the *Ariel* left Harwich', and he was indignant when the Rev. Kingsley told him that his mother had been through a similar experience and understood what he was getting at. 'I did not paint it to be understood,' Turner said, 'but I wished to show what such a scene was like: I got the sailors to lash me to the mast to observe it; I was lashed for four hours, and I did not expect to escape, but I felt bound to record it, if I did. But no one had any right to like the picture.' In this case the design of his picture, with its intersecting arcs and the steep tilt of the wild sea was not imposed from outside, but formed part of the scene he had witnessed with such heroic intensity, and recorded in his remarkable memory. Kingsley's mother apart, there were few who had looked into such a storm, fewer still who could appreciate his transcription of it. One critic called it 'soapsuds and whitewash', recalling the complaints made forty years before that his waves were chalky and his sea looked like soap and chalk. He dined with the Ruskins when this criticism was made and sat muttering to himself: 'Soapsuds and whitewash? What would they have? I wonder what the sea's like? I wish they'd been in it.' The injustice of the criticism fired Ruskin with the determination to reply, as he had done abortively when *Juliet and her nurse* was attacked in 1836. His defence of Turner was planned as a pamphlet, but grew under its own momentum to the five volumes of *Modern Painters*, of which the first two were published in the artist's lifetime, in 1843 and 1846. Conceived in terms of the highest panegyric, the work never pleased Turner, and Ruskin noted that he hardly got thanks from him for it. That Ruskin had a passionate devotion to Turner's later work, and the instinctive appreciation of a large part of his achievement, cannot be denied. By the strength of his rhetoric and the particularity of his descriptions he forced numbers of people to look at paintings or at least to look more closely at nature and

190

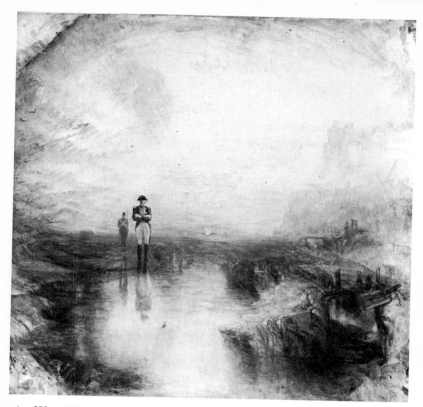

164 *War: The exile and the rock limpet* 1842

compare paintings with what they saw. But for Turner the emphasis was placed far too much on his topographical work at the expense of the historical and epic landscape by which he himself set so much more store. Again, as Ruskin records, Turner could not bear to hear the work of a contemporary disparaged without making the best possible defence and emphasizing the difficulty of painting at all. He could not be expected to relish finding himself praised at the expense of a total denigration of Claude. He had said of the Altieri *Sacrifice of Apollo*, 'It seemed to be beyond the power of imitation': one of Ruskin's dismissive phrases is, 'exquisite as is Claude's instinct for blunder, he had not strength of mind enough to

blunder into a wholly original manner'. Ruskin defended himself by saying that his real targets were Stanfield, Creswick, Martin, Lee, and Harding and that he attacked Claude because he could not attack the living; but Turner is unlikely to have been impressed by this argument.

Throughout the 1830s Turner had been making use of water-colour, with ever-increasing boldness, for the same purposes as before; some sketching on his journeys, designs for engraving, including the illustrative vignettes, and more elaborate topographical views. For the views in particular he had a steady band of patrons, and from 1834 a new dealer, Thomas Griffith, took charge of their disposal. One of the last of these transactions was undertaken in 1841, when Turner wanted to raise the money to finance five large engravings of his most important pictures. He took fifteen coloured sketches he had recently made in Switzerland and on the Rhine, with four finished drawings, to Griffith and asked him to get commissions for as many as possible. Although the group included the long-famous *Red Righi* (originally *Mont Righi, morning*) and *Blue Righi* (originally *Mont Righi, evening*) the market had begun to contract, and only nine were disposed of. That Ruskin failed to acquire a particular one of them, the *Pass of the Splügen*, from its original purchaser, Munro of Novar, remained a perennial collector's grievance with him, for he said of it, 'I knew perfectly well that this drawing was the best Swiss landscape yet painted by man; and that it was entirely proper for *me* to have it, and inexpedient that anybody else should.'

In 1843 Turner sent six pictures to the Royal Academy. One was the topical but ill-fated *The Opening of the Walhalla, 1842*. Three others were Venetian scenes of which *The Sun of Venice going to sea* and *St Benedetto, looking towards Fusina* were at once recognized as especially successful. In the other two exhibits, *Shade and darkness – the evening of the Deluge* and *Light and colour (Goethe's Theory) – the morning after the Deluge – Moses writing the book of Genesis*, he tried to extend the cosmological

Ill. 165

Ill. 157

Ill. 161
Ill. 163

166 *Funeral at Lausanne*, page from a sketchbook of 1841

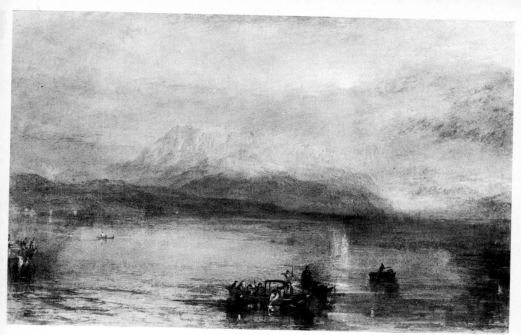

165 *Red Righi* 1841

range of his art. The immediate occasion of this pair of paintings had been the publication in 1840 of Eastlake's translation of Goethe's *Zur Farbenlehre*. Turner's annotated copy shows that he had read it with the same concentration on scientific thought as he had shown in his study of perspective and was to show again when he visited the studio of the photographer Mayall and questioned him closely on the basis of his work.

He had the distrust of rules for art common to many pragmatic English painters – Hilliard and Hogarth among them. But the preciseness and lucidity of Goethe's description of the colour phenomena he observed appealed to him. For instance, 'I happened to be in a forge towards evening at the moment when a glowing mass of iron was placed on the anvil', followed by a description of the after-image. And the dominant place which Goethe assigned to yellow in his theory was a direct parallel to his own practice. Most painters develop a personal colour range. When Turner began in the tradition of the late eighteenth-century watercolourists blue was the dominant note: 'O ye Gods! the blue bag–the blue bag', said Edward Dayes, examining the work of a pupil of Girtin. Indeed, one of the novelties in Constable, which made him difficult for his age to accept, was his addiction to the green of vegetation. 'That's a nasty green thing', said his Academy colleagues, condemning a picture of his. Turner had progressed from the darker tonalities and the dependence on *chiaroscuro* of his early work, the 'minus' colours of Goethe, to that point in his later style, seen at its purest in the 'Colour Beginnings' in which he uses pure colour for its psychological effects. By now the dominant note in his pictures was yellow, and Goethe grades yellow as the first derivative of the highest degree of light, associating with it a 'serene, gay, softly exciting character'. Blue he places at the furthest end of the scale, the first derivative of darkness and 'gloomy and melancholy' in its associations. Thus blue and the other derivatives of black, or 'minus' colours, were a natural gamut for the theme of *The evening of the Deluge*, and yellow with the other positive colours such as green and

Ill. 128

Ill. 161

194

167 *Coblenz*, from a sketchbook used at Heidelberg and other German cities in 1844

168 *Figures in a storm c.* 1830

scarlet were appropriate to *The morning after the Deluge*. But the paintings have more interpretative content than these abstract colour notions might suggest. The deluge theme, already treated by Turner in the painting he showed in 1813, had become an important element in Protestant iconography. John Martin had given it a more telling impact in his greatly elaborated architectural fantasies, and himself exhibited *The deluge* at the Royal Academy in 1837, a composition also well known from the mezzotint. It is interesting, though possibly only a coincidence, that Goethe was an adherent of the view that the origin of the earth's rocks was to be sought in the water covering given by the Deluge. In the verses from the *Fallacies of Hope* which he added to the picture's title, Turner accepted the traditional idea that man's disobedience caused the Deluge, but he was probably aware of the wider debate on the scientific and geological significance of the Biblical Flood which was active at this period. The great sense of vitality and movement in the picture is provided by the serpentine line of animals wending towards the Ark, which is floating on the waters at the centre of the picture; their action is like a jetty stretching out into a cone. Amongst the remarkable colour effects is the contrast between the natural light of the setting sun and the artificial light illuminating the heedless victims in their rough shelter in the foreground.

A similar or greater complexity of reference was introduced into the pendant illustrating the morning after the deluge. The elucidatory verses read:

> *The ark stood firm on Ararat: the returning sun*
> *Exhaled earth's humid bubbles, and emulous of light,*
> *Reflected her lost forms, each in prismatic guise;*
> *Hopes harbinger, ephemeral as the summer fly*
> *Which rises, flits, expands and dies.*

Conceived in Goethe's gamut of 'plus', or vivacious colours, it achieves in tonality a complete contrast of mood with the stillness of the earlier scene. The introduction of Moses writing

the Book of Genesis makes the scene a sort of creative symbol, and the serpent twisted on a rod may be a reference to the myths of creation as well as to the occasion when Moses' staff was transformed in this way. The bubbles of the poem and the picture itself are a commentary on a passage of Goethe's theory, in which he draws attention to the origin of prismatic colours in the surface of a bubble. The globular form of the composition recalls Turner's experiments, for his lectures, on reflections in polished spherical surfaces.

These vehicles of Turner's more tragic view of life – the 'dark clue' as Ruskin called it – were virtually unintelligible to his contemporaries, and it may have been to make them more acceptable, or less conspicuous, that he persevered with his series of Venetian views, showing them at the same time. In the following year, 1844, he had three scenes of Venice at the Academy and three sea-pieces with a Low Country accent. Besides these, his most original exhibit was the view of a railway train crossing the recently completed bridge between Maidenhead and Taplow which he called *Rain, Steam and Speed – The* *Ill. 162* *Great Western Railway*. Once again this was based – it is said – like the storms in *Snow storm: Hannibal and his army crossing the Alps* and *Snow storm – steamboat off a harbour's mouth*, on a personal experience. An old friend of Ruskin's told him that she was travelling to London on the Exeter express when an old gentleman in the carriage asked permission to open the window. He put his head into a rainstorm for nine minutes, observing and memorizing; and next year she saw the picture at the Academy. The hare running along the track in front of the train is a characteristically playful touch indicating the limits on the engine's speed. The composition is dominated by the jetty-like form of the bridge entering from the right, a device he had explored in the illustrations to Campbell's *Poems* and used in *Juliet and her nurse* and *The burning of the Houses of* *Ill. 147* *Parliament*.

Always eager to augment his scientific knowledge, Turner read *The Natural History of the Sperm Whale* by Thomas Beale,

169 *Coach at Eu*, from a sketchbook used at Eu and Tréport in 1845

which was published in 1839. This provides the text for four paintings, two of which he showed at the Academy in 1845 and two in 1846. It was probably at this time that he brought some of his 'Colour Beginnings' to a sort of completeness by adding to their sunset effects the form of a sea monster. At the age of seventy, in 1845, he was active enough, after exhibiting six works at the Academy, to go as far as Dieppe and Le Tréport looking 'for storms and sunsets'. At Eu, where he made some of his most evocative late sketches, he was invited to dinner by King Louis-Philippe, who had been his neighbour at Twickenham and would take no denial.

Ills. 169, 170

Themes of energy still concerned him as well as wrecks. For the 1846 Exhibition, the penultimate occasion on which he spurred himself to make a big and varied effort, he prepared,

198

170 *Interior of church*, from the same sketchbook as *Ill. 169*. 1845

171 *Whalers* 1845

Ill. 171
Ill. 173 besides the *Whalers* and two Venice scenes, an operatic vision
of *Undine giving the ring to Masaniello, fisherman of Naples.* We
are as ignorant of Turner's visits to the theatre as of many other
aspects of his life; but here he seems to be combining a know-
ledge of Perrot's ballet *L'Ondine*, in which the name part was
created by Fanny Cerito at Her Majesty's Theatre in 1843,
with an earlier recollection of Auber's opera *Masaniello*, pro-
duced in London in 1829.

To the British Institution he sent, the same year, his *Queen
Mab's Cave*, with a quotation – 'Thy orgies, Mab, are manifold.'
And in his other Academy exhibit he explored again the world
of ideas and forms which he had advanced in 1843 with the
two Ark paintings. This apocalyptic painting in the circular,
Ill. 172 vortical framework was *The Angel standing in the sun.* To the

200

172 *The Angel standing in the sun* 1846

173 *Undine giving the ring to Masaniello, fisherman of Naples* 1846

title he added the verses from the Book of Revelation in which the angel invokes the birds to feast on 'the flesh of kings, and the flesh of mighty men, and the flesh of horses . . .', and the couplet from Rogers' *The Voyage of Columbus*:

> *The morning march that flashes to the sun;*
> *The feast of vultures when the day is done.*

Mr Lindsay has pointed out that Ruskin had referred to Turner as the Angel of the Apocalypse in a passage expurgated from later editions of *Modern Painters* because it was felt to be blasphemous. This may well have suggested the subject, though Turner hardly seems to be identifying himself with the central figure in the picture, in which he may well have in mind one

174 *Skeleton falling off a Horse c.* 1830

175 *Hero of a Hundred Fights* 1846

of Martin's angels. It is an allegory of death, and of murder, if
the foreground figures are correctly identified as Adam and Eve
lamenting the death of Abel, and Judith with Holophernes.
The Skeleton of Death is a reminiscence of another Dance of
Death theme Turner painted late in his career – the *Skeleton
falling off a Horse* which seems related to West's *Death on the
Pale Horse*. The light emanating from the sun, white veering to
yellow and intense red, absorbs and destroys its victims as fully
as the birds of prey on the outer rim of this vortex.

Ill. 174

This painting is dominated by its creative energy, and the
same vitality is found in the sketches he made in watercolour
at Eu in 1845. But now Turner was over seventy, and his
health was at last beginning to fail. There are frequent references

to this throughout the 1840s, and his troubles were increased by the loss of his teeth. The difficulty he had in dining out made him more withdrawn than ever, and now he spent much of his time in seclusion in his cottage on the river at Cheyne Walk, passing locally by the name of Mr Booth. He had installed Mrs Booth there and she looked after him to the end, but little of this became known even to his closest associates. His last sketchbook is assigned to 1846 or 1847, and its views of Margate show that he returned with Mrs Booth to her former home.

Ill. 175 In 1847 he was only strong enough to send one picture to the Academy. This was the *Hero of a Hundred Fights*, and was again topical, since it represented the casting of the statue of the Duke of Wellington by M. C. Wyatt, which had taken place in the previous September. Here his hero is apotheosized by the blaze of light emanating from the foundry. As well as the references he makes to the German invocation when a bell is cast he may also have had in mind the description by Goethe of his visit to a foundry.

It was this year that an artist said to Turner on one of the 'varnishing days', 'Why Turner – you have but one picture here this year', and he replied, 'Yes, you will have less next year.' And, in fact, there was nothing shown by him in 1848 – his first lapse in twenty-four years. In 1849 he sent the early *Venus and Adonis* and *The Wreck Buoy* in which he had transfigured another early work, painted about forty years before. He had borrowed it back from Munro of Novar and made of it a virtually new creation, with a double rainbow, and a clear demonstration of the gulf between his earlier and his later styles.

For 1850 he summoned his energies for what he probably realized to be his last showing of all at the Academy. He chose, for this supreme and final effort, to return to the story of Dido and Aeneas which had captivated him for so long, and treated it in four companion pictures. Three of them follow the narrative given by Virgil in the *Aeneid*, though the quotations he put with them are from the *Fallacies of Hope*; these episodes are *Aeneas relating his story to Dido, Mercury sent to admonish*

176 *The visit to the tomb* 1850

Aeneas and *The departure of the fleet*. The fourth seems to be an invention of his own, in which he imagines Dido visiting the tomb of her husband Sychaeus with Aeneas and Cupid. This he called *The visit to the tomb*, and quoted from the *Fallacies of Hope* the line: 'The sun went down in wrath at such deceit.' The whole story, and this theme with it, is a fitting illustration of Turner's lifelong preoccupation with the frustration of human plans. In the execution he achieved a balance between making the historical figures identifiable and yet dissolving the solidity of the architecture and landscape of Carthage in a prismatic glow of rich, golden colour. Besides dwelling on the deceit of Aeneas, he may in this painting have had a personal reference in mind. It is at the least a strange coincidence that one of his last finished pictures was the serene *Visit to the tomb*.

Ill. 176

205

That Christmas he received his customary present of game pie from Farnley Hall and wrote in return, 'Old Time has made sad work with me . . . I always dreaded it with horror, now I feel it acutely.' Although he sent nothing to the Academy in 1851 he attended the 'varnishing days'. He had been interested in the shape being assumed by the Crystal Palace, and throughout the year there are references to his dining out and showing vigour of eye and mind. But when David Roberts tried to find out where he was spending most of his time he replied, 'You must not ask me.'

A few years earlier Turner had been a guest at a dinner given at Greenwich to Charles Dickens. Forster recorded that he 'enjoyed himself in a quiet silent way, less perhaps at the speeches than at the changing lights on the river'. In his final home in Cheyne Walk he could watch those lights from the balcony without stirring from his house. He had been born within a few yards of the Thames, and he died in a room looking over it. The doctor who was present at his death, on 19 December 1851, wrote, 'just before 9 a.m. the sun burst forth and shone directly on him with that brilliancy which he loved to gaze on. He died without a groan. . . .'

He was buried in St Paul's Cathedral, in the presence of many of his fellow academicians. Mrs Booth and Hannah Danby, the housekeeper at his dilapidated gallery in Queen Ann Street, were there; and, as he had wished, his body was placed beside the tombs of Reynolds and Lawrence. Of the dispositions he made in his will the desire to disinherit his next-of-kin and devote his monetary estate to the foundation of an institution for indigent male English artists was frustrated. His artistic estate, some 350 paintings and nearly 20,000 watercolours and drawings, became the property of the nation, though a special gallery was not built for them as he had desired. Turner himself would have regarded this outcome as another example of the 'Fallacies of Hope'.

An essential part of Turner's career is its directed quality. In retrospect his progression from a topographical water-

colourist to a prophet and poet in colour has a sense of inevitability and forethought. In nothing is this more evident than in his provision for the future understanding of his aim. As we know, he felt that his contemporaries, including Ruskin himself, did not fully enter into his meanings. But relatively early in his career he started buying back the works he valued most amongst those he had sold, and ultimately he came to plan more and more that the greater part of his production should be kept together and belong to the nation. His desire to be reviewed as a whole is in line with his wish for all the drawings in the various series of views to be kept together. He disliked having one of a number of similar watercolours extolled above another; as Ruskin recorded from his own experience 'there were few things he hated more than hearing people gush about particular drawings. He knew it merely meant they would not see the others.' So as he formulated his successive wills after the death of his father he extended the range of his bequest. At first it was to be his finished works; then, ultimately, it was everything in his studio, finished or sketched. It is to this final provision, which was carried out, that we owe the opportunity of seeing not only a great range of his exhibited pieces, but also the 'Colour Beginnings' and the experiments in the rendering *Ills. 128–31* of light and colour which are his most advanced creations and do so much to throw light on his later pictures, misunderstood as they were by his own age.

The width of his ambition, and the strength of his achievement in so many diverse fields, is such that, even with the help which its assembly in two or three centres gives, it is hardly possible to comprehend it all in one act of judgment or reduce it to practicable proportions. He is a topographer who in his renderings of picturesque views and Gothic ruins equalled the finesse of the late-eighteenth-century school of English watercolourists. Then into his later topographical paintings and watercolours he introduced an unrivalled technical ability, a virtuosity in the handling of paint, and a poetic distribution of the sheer material facts of the scene which set him apart from

other landscape painters. In his early sea-pieces he competed with the seventeenth-century Dutch school. In his figure subjects he emulated Stothard and, in the Petworth interiors, achieved a new form of intimate description. Probably what he had most nearly at heart was the elevated landscape painting of historical or mythological subjects which he strove to re-create in the wake of the seventeenth century. The earliest attempts he made at this were in the guise of Poussin and Claude; then the imagery of Claude becomes an allusion as his ideas of colour become more and more radical. And of these historical landscapes it seems likely that the ones which most fully expressed his purpose, in which he created freely without the necessity for dependence on earlier models, were those he exhibited during the last years of his life, *Shade and darkness – the evening of the Deluge, Light and colour (Goethe's Theory) – the morning after the Deluge, The Angel standing in the sun*, and the four paintings on the theme of Dido and Aeneas which formed his last exhibits of all.

Ill. 161
Ill. 163
Ill. 172

Ill. 176

That it was in such works that he sought the judgment of posterity is seen in the statements he made in his lectures, in his desire to establish a Professorship of Landscape Painting, and in the provisions of his bequest. Like all artists he had had to create the taste by which he is understood. There has been so much which was admirable at any stage of his career that his own culminating point may have been overlooked. But the internal growth of the art of painting has itself created the taste by which more and more of the work which was not only unintelligible in its own day but remained unappreciated into the twentieth century is now accessible and can become the vehicle of communication. He was a genius not only in the volume and energy of his work, but also in its inexhaustibility as a source of fresh experience.

Bibliography

List of Illustrations

Index

Short Bibliography

Of the two standard biographies, Walter Thornbury's *The Life of J. M. W. Turner, R.A.* (1st ed. 1862; 2nd ed. 1877) makes entertaining reading and incorporates a number of contemporary accounts, but is highly unreliable. A. J. Finberg's *The Life of J. M. W. Turner* (1st ed. 1939, 2nd ed. 1961) is in the main accurate; it is a painstaking compilation, but unimaginatively written and lacks a certain sense of historical perspective. Ruskin's copious writings about Turner are scattered throughout his works; they are fully indexed in the Library Edition by E. T. Cook and Alexander Wedderburn, Vol. 39, 1912.

Amongst more recent works, *Turner* by John Rothenstein and Martin Butlin, 1964, is especially valuable for the large corpus of illustrations. Martin Butlin's *Turner; Watercolours*, 1962, contains 32 colour reproductions of remarkable fidelity. Jack Lindsay's *J. M. W. Turner; his life and work*, 1966, gives a personal assessment on political and psychological lines; it advances a number of ingenious theories and includes an excellent full bibliography. Lawrence Gowing's *Turner; Imagination and Reality*, 1966, written for the important loan exhibition of late paintings at the Museum of Modern Art, New York, provides a fresh and original approach to yet other aspects of this many-sided artist. The introduction to Michael Kitson's *J. M. W. Turner* (Blandford Press 1964) contains a balanced account of the artist's sources and development.

List of Illustrations

$4\frac{1}{4} \times 7\frac{1}{4}$. British Museum, CV p. 68.

41 *Shipwreck c.* 1805. Pen and ink and wash $4\frac{1}{2} \times 7\frac{1}{4}$. British Museum, LXXXVII p. 16.

42 *The Shipwreck* 1805. Exh. Turner's Gallery 1805. Oil $67\frac{1}{2} \times 95$. Tate Gallery, London, 476.

43 *A country blacksmith* 1807. Exh. RA 1807. Oil on panel $22\frac{1}{2} \times 30\frac{1}{2}$. Tate Gallery, London, 478.

44 *Death of Liseus* (?) *c.* 1805–7. Pen and ink $5\frac{3}{4} \times 9$. British Museum, XCIV p. 15.

45 *The Goddess of Discord* 1806. Exh. British Institution 1806. Oil $59\frac{1}{2} \times 84$. Tate Gallery, London, 477.

46 *The Battle of Trafalgar* 1805–8. Oil 68×94. Tate Gallery, London, 480.

47 *Tabley, windy day* 1808. Oil $36 \times 47\frac{1}{2}$. By kind permission of Lt.-Col. J. L. B. Leicester-Warren.

48 *Otley, from Caley Park c.* 1812. Pencil $11\frac{1}{2} \times 18\frac{1}{2}$. British Museum, CXXVIII p. 40.

49 *Windsor c.* 1809. Oil $40 \times 50\frac{1}{2}$. Tate Gallery, London, 486.

50 Study for *Windsor Castle c.* 1805–6. Watercolour $5\frac{3}{4} \times 10$. British Museum, XC p. 29a.

51 Study for *The Sun rising through vapour c.* 1800–5. Black and white chalk $10\frac{3}{4} \times 17\frac{1}{4}$. British Museum, LXXXI p. 56.

52 *The Sun rising through vapour* 1807. Oil $53 \times 70\frac{1}{2}$. Courtesy of the Trustees of the National Gallery, London, 479.

53 *Men with a windlass c.* 1796–7. Watercolour $7\frac{1}{8} \times 10\frac{5}{8}$. British Museum, XXXIII Q.

54 *Calais Pier* 1803. Oil $67\frac{3}{4} \times 94\frac{1}{2}$. Courtesy of the Trustees of the National Gallery, London, 472.

55 *The artist* 1809. Pen and ink watercolour $7\frac{1}{4} \times 11\frac{3}{4}$. British Museum, CXXI B.

56 *A road and trees beside a river c.* 1809–10. Sepia $9\frac{1}{8} \times 14\frac{3}{4}$. British Museum, CXV p. 1.

57 *The Thames near Walton*

Bridge c. 1806–7. Oil on panel $14\frac{5}{8} \times 29$. Tate Gallery, London, 2680.

58 *Wells' Kitchen, Knockholt c.* 1806–7. Oil on sized paper $10\frac{3}{4} \times 14\frac{1}{2}$. British Museum, XCV(a) A.

59 *Junction of Severn and Wye* 1811. Engraving $8\frac{1}{4} \times 11\frac{1}{2}$. Victoria and Albert Museum, 21259–15.

60 Sketch probably for *Crossing the brook* 1812 or 1813. Pencil $6\frac{1}{4} \times 7\frac{1}{2}$. British Museum, CXXI p. 118.

61 *Perspective diagram c.* 1811. Pencil, pen, ink and wash $26\frac{1}{4} \times 39\frac{1}{2}$. British Museum, CXCV 99.

62 *Perspective diagram c.* 1811. Watercolour $26\frac{1}{4} \times 39\frac{1}{2}$. British Museum, CXCV 97.

63 *Cottage destroyed by an Avalanche* 1810. Oil $35\frac{1}{2} \times 47\frac{1}{4}$. Tate Gallery, London, 489.

64 *Glass balls, partly filled with water.* Watercolour $17\frac{1}{2} \times 26\frac{1}{2}$. British Museum, CXCV 177.

65 *Snowstorm: Hannibal and his army crossing the Alps.* Exh. RA 1812. Oil 57×93. Tate Gallery, London, 490.

66 *Bolton Abbey c.* 1812–15. Pencil $7 \times 10\frac{1}{4}$. British Museum, CCXXXIV p. 75.

67 *Frosty Morning* 1813. Exh. RA 1813. Oil $44\frac{3}{4} \times 68\frac{3}{4}$. Tate Gallery, London, 492.

68 *Study of a Carthaginian subject c.* 1815–16. Pencil $3\frac{3}{4} \times 6$. British Museum, CXLIV p. 101a.

69 *Dido building Carthage* 1815. Exh. RA 1815. Oil $61\frac{1}{4} \times 91\frac{1}{4}$. Signed. Courtesy of the Trustees of the National Gallery, London, 498.

70 *The decline of the Carthaginian Empire* 1817. Exh. RA 1817. Oil $67\frac{1}{2} \times 95$. Tate Gallery, London, 499.

71 *Appullia in search of Appullus.* Exh. British Institution 1814. Oil 57×93. Tate Gallery, London, 495.

72 *Crossing the brook.* Exh. RA 1815. Oil 76×65. Tate Gallery, London, 497.

73 *Dort or Dortrecht.* Exh. RA 1818. Oil 62×92. From the collection of Mr and Mrs Paul Mellon.

74 *First Rate Taking in Stores* 1818. Watercolour and pencil $11\frac{1}{4} \times 15\frac{5}{8}$. By courtesy of the Trustees of the Cecil Higgins Art Gallery, Bedford.

75 *Study of wild flowers c.* 1815–17. Pen and ink $4\frac{1}{2} \times 6\frac{1}{4}$. British Museum, CXLII p. 8.

76 *Scarborough.* Watercolour $13\frac{3}{4} \times 17\frac{1}{4}$. British Museum, CXCVI B.

77 *Study of shipping, Scarborough c.* 1816–18. Pencil $4\frac{1}{2} \times 7\frac{1}{8}$. British Museum, CL p. 20.

78 *Watchet, Somerset* 1811. Pencil $3 \times 4\frac{1}{2}$. British Museum, CXXIII p. 170a.

79 *The field of Waterloo* 1817. Pencil $3\frac{3}{4} \times 5\frac{7}{8}$. British Museum, CLX p. 21a.

80 *A Man galloping c.* 1816–18. Pencil $4\frac{1}{2} \times 7\frac{1}{8}$. British Museum, CL p. 29.

81 *A bridge in the West Country c.* 1812–13. Oil on board $6\frac{1}{2} \times 10\frac{1}{4}$. British Museum, CXXX F.

82 *View of the Temple of Jupiter Panellenius* 1814. Exh. RA 1816. Oil $46\frac{1}{4} \times 70$. Owned by His Grace the Duke of Northumberland.

83 *Schloss Stolzenfels* 1817. Pencil $8 \times 10\frac{1}{2}$. British Museum, CLXI p. 16.

84 *A colour sketch* 1818–20. Pencil, Indian ink and watercolour $7 \times 10\frac{1}{8}$. British Museum, CLXX p. 13.

85 *Sketches of buildings and trees at Raby Castle c.* 1817. Pencil $9\frac{1}{8} \times 13$. British Museum, CLVI p. 22a.

86 *England: Richmond Hill* 1819. Exh. RA 1819. Oil 70×132. Tate Gallery, London, 502.

87 *Raby Castle.* Exh. RA 1818. Oil $46\frac{3}{4} \times 71$. The Walters Art Gallery, Baltimore.

88 'Colour Beginning': *Thames from Richmond Hill.* Watercolour $12\frac{1}{2} \times 22\frac{1}{4}$. British Museum, CCLXIII 348.

89 'The first bit of Claude' 1819.

Pencil $4\frac{3}{8} \times 7\frac{7}{8}$. British Museum, CLXXVII p. 6.

90 *Turin Cathedral* 1819. Pencil $4\frac{3}{8} \times 7\frac{7}{8}$. British Museum, CLXXIV p. 28.

91 *The Passage of Mont Cenis: Snowstorm* 1820. Watercolour 28×40. By permission of the Birmingham Museum and Art Gallery.

92 *The Colosseum, Rome* 1819. Watercolour $5\frac{1}{4} \times 10\frac{1}{2}$. British Museum, CXC p. 4.

93 *The Roman Campagna* 1819. Watercolour 10×16. British Museum, CLXXXVII p. 34.

94 *Rome from the Vatican* 1820. Exh. RA 1820. Oil $69\frac{1}{2} \times 131$. Tate Gallery, London, 503.

95 *Scarborough* 1826. Watercolour $6\frac{1}{4} \times 8\frac{7}{8}$. British Museum, CCVIII 1.

96 *Hornby Castle* c. 1822. Watercolour $11\frac{1}{2} \times 16\frac{1}{2}$. Victoria and Albert Museum.

97 *George IV at a Banquet* 1822. Oil on panel $26\frac{1}{4} \times 36\frac{1}{2}$. Tate Gallery, London, 2858.

98 *Landscape with figures* c. 1823–4. Monochrome wash $3\frac{7}{8} \times 6\frac{3}{8}$. British Museum, CCV p. 27.

99 *An Avenue* 1822–3. Watercolour $7 \times 10\frac{1}{2}$. British Museum, CCII p. 22.

100 *Red Sunset* 1826. Drawing in body colour on blue paper $5\frac{1}{2} \times 7\frac{1}{2}$. British Museum, CCXXI J.

101 *The Bay of Baiae.* Exh. RA 1823. Oil $57\frac{1}{2} \times 93\frac{1}{2}$. Tate Gallery, London, 505.

102 *Mortlake* 1826. Exh. RA 1826. Oil $35 \times 47\frac{1}{2}$. Copyright the Frick Collection, New York.

103 *Trèves* 1826. Watercolour $8\frac{3}{4} \times 11\frac{1}{4}$. British Museum, CCXVIII p. 10.

104 *The Battle of Trafalgar* c. 1823. Oil 103×145. National Maritime Museum, Greenwich.

105 *Between Decks* 1827. Oil $12 \times 19\frac{1}{8}$. Tate Gallery, London, 1996.

106 *Yacht racing in the Solent* (1) 1827. Oil $18 \times 28\frac{1}{4}$. Tate Gallery, London, 1993.

107 *East Cowes Castle* 1828. Oil $36 \times 48\frac{1}{2}$. Victoria and Albert Museum, FA 210.

108 *Boccaccio relating the tale of the birdcage* 1828. Exh. RA 1828. Oil 48×36. Tate Gallery, London, 507.

109 *Pilate washing his hands* 1830. Exh. RA 1830. Oil 36×48. Tate Gallery, London, 510.

110 *Orvieto* 1828. Exh. Rome 1828, RA 1830. Oil $36 \times 48\frac{1}{2}$. Tate Gallery, London, 511.

111 *Ulysses deriding Polyphemus* 1829. Exh. RA 1829. Oil $52\frac{1}{4} \times 80\frac{1}{2}$. Courtesy of the Trustees of the National Gallery, London, 508.

112 Sketch for *Ulysses deriding Polyphemus.* Oil $23\frac{5}{8} \times 35\frac{1}{8}$. Tate Gallery, London, 2958.

113 *Music party, Petworth* 1830–7. Oil $47\frac{3}{4} \times 35\frac{5}{8}$. Tate Gallery, London, 3550.

114 *Interior at Petworth* c. 1830–7. Oil $35\frac{3}{4} \times 48$. Tate Gallery, London, 1988.

115 *The picture gallery, Petworth* c. 1830. $5\frac{1}{2} \times 7\frac{1}{2}$. Drawing in body colour on blue paper. British Museum, CCLIV p. 13.

116 *Interior of a room at Petworth* c. 1830. $5\frac{1}{2} \times 7\frac{1}{2}$. Drawing in body colour on blue paper. British Museum, CCXLIV p. 19.

117 *Lady trying on a glove* c. 1830. Oil $47\frac{3}{4} \times 35\frac{3}{4}$. Tate Gallery, London, 5511.

118 *Jessica* 1830. Exh. RA 1830. Oil 47×35. H.M. Treasury and the National Trust. From the Petworth Collection.

119 *Chichester Canal* c. 1830–1. Oil $25\frac{3}{4} \times 53$. Tate Gallery, London, 560.

120 *Petworth Park* c. 1830. Oil $25\frac{1}{4} \times 58\frac{1}{4}$. Tate Gallery, London, 559.

121 *Landscape with water* c. 1835–40. Oil $48 \times 71\frac{3}{4}$. Tate Gallery, London, 5513.

122 *Norham Castle, sunrise* c. 1840–5. Oil 36×48. Tate Gallery, London, 1981.

123 *Woman reclining on a couch* c. 1830–1. Oil $68\frac{3}{4} \times 98$. Tate Gallery, London, 5498.

124 *Watteau study* 1831. Exh. RA 1831. Oil on panel $15\frac{3}{4} \times 27\frac{1}{2}$. Tate Gallery, London, 514.

125 *Vessel in distress off Yarmouth.* Exh. RA 1831. Oil 36×48. Victoria and Albert Museum, FA 211.

126 *The Evening star* 1830. Oil $36\frac{1}{4} \times 48\frac{1}{4}$. Courtesy of the Trustees of the National Gallery, London, 1991.

127 *Plymouth Hoe* 1832. Watercolour $11 \times 16\frac{1}{4}$. Victoria and Albert Museum, 521–1882.

128 'Colour Beginning': *Sunrise over the waters* after 1825. Watercolour $13\frac{3}{4} \times 19\frac{1}{2}$. British Museum, CCLXIII 42.

129 'Colour Beginning': *Cartmel Sands* after 1828. Watercolour 12×19. British Museum, CCLXIII 160.

130 'Colour Beginning'. Watercolour $6\frac{3}{4} \times 9\frac{1}{2}$. British Museum, CCLXIII 288.

131 'Colour Beginning': *Oxford High Street.* Watercolour $14\frac{1}{2} \times 21\frac{1}{2}$. British Museum, CCLXIII 5.

132 *Lake Nemi* c. 1828–9. Oil $23\frac{3}{4} \times 39\frac{1}{4}$. Tate Gallery, London, 3027.

133 *Coast scene near Naples* c. 1828. Oil $16\frac{1}{8} \times 23\frac{1}{2}$. Tate Gallery, London, 5527.

134 *A harbour with a town and fortress* c. 1835–40. Oil $67\frac{3}{4} \times 88$. Tate Gallery, London, 5514.

135 *Staffa. Fingal's Cave.* Exh. RA 1832. Oil 36×48. By kind permission of the Hon. Gavin Astor.

136 Vignette to Rogers' *Poems* 1834. Watercolour $2\frac{7}{8} \times 3\frac{1}{4}$. British Museum, CCLXXX 209.

137 *The evil spirit* Vignette to Rogers' *Poems* 1834. p. 264. Watercolour $3\frac{1}{4} \times 3$. British Museum, CCLXXX 202.

138 *The Phantom Ship.* Engraving for Rogers' *Poems* 1834. p. 233. $3 \times 3\frac{1}{4}$. Victoria and Albert Museum.

139 *Villa Madama: moonlight.* Engraving for Rogers' *Italy.* 1830. p. 135. 3×3. Victoria and Albert Museum.

140 *Hohenlinden.* Engraving for Campbell's *Poems* p. 100. $4\frac{1}{4} \times 2\frac{7}{8}$. Victoria and Albert Museum.

141 *Bridge of Sighs. Ducal Palace and Custom House, Venice* 1833. Exh. RA 1833. Oil on panel 20×32. Tate Gallery, London, 370.

142 *The Burning of the Houses of Lords and Commons.* Exh. RA 1835. Oil $36\frac{1}{2} \times 48\frac{1}{2}$. The Cleveland Museum of Art, John L. Severance Collection, 1936.

143 *Keelmen heaving in coals by night.* Exh. RA 1835. Oil $36\frac{1}{4} \times 48\frac{1}{4}$. National Gallery of Art, Washington.

144 *The golden bough* 1834. Oil $41 \times 64\frac{1}{2}$. Tate Gallery, London, 371.

145 *Open air theatre, Venice* 1835. Watercolour and bodycolour on brown paper $9\frac{1}{2} \times 12$. British Museum, CCCXVIII 4.

146 *Figures on a bridge, Venice* 1835. Watercolour and bodycolour on brown paper $9\frac{1}{2} \times 12$. British Museum, CCCXVIII 24.

147 *Juliet and her nurse* 1836. Exh. RA 1836. Oil $35 \times 47\frac{1}{2}$. By kind permission of Mrs Miller, Long Island.

148 *Snowstorm, avalanche, and inundation.* Exh. RA 1837. Oil $36\frac{1}{4} \times 48$. Art Institute of Chicago.

149 *Modern Italy: The Pifferari* 1838. Exh. RA 1838. $36\frac{1}{2} \times 48\frac{1}{2}$. Glasgow Museums and Art Galleries.

150 *Phryne going to the public bath as Venus* 1838. Exh. RA 1838. Oil. 76×65. Tate Gallery, London, 522.

151 Sketch for *The parting of Hero and Leander c.* 1800–5. Black and white chalk $10\frac{3}{4} \times 17\frac{1}{8}$. British Museum, LXXXI p. 57.

152 *The parting of Hero and Leander* 1837. Exh. RA 1837. Oil $57\frac{1}{2} \times 93$. Courtesy of the Trustees of the National Gallery, London, 521.

153 *The Fighting 'Temeraire' 1838.* Exh. RA 1839. Oil $35\frac{3}{4} \times 48$. Courtesy of the Trustees of the National Gallery, London, 524.

154 *Slavers throwing overboard the dead and dying* 1840. Exh. RA 1840. Oil $35\frac{3}{4} \times 48$. Courtesy, Museum of Fine Arts, Boston, Henry Lillie Pierce Fund.

155 *Rockets and blue lights.* Exh. RA 1840. Oil 35×48. Courtesy of the Sterling and Francine Clark Art Institute, Williamstown, Massachusetts.

156 *Rough sea c.* 1830–2. Oil $36 \times 48\frac{1}{4}$. Tate Gallery, London, 1980.

157 *The Opening of the Walhalla 1842.* Exh. RA 1843. Oil on panel $44\frac{1}{2} \times 79$. Tate Gallery, London, 533.

158 *Venice from the Canale della Giudecca* 1840. Exh. RA 1840. Oil 24×36. Victoria and Albert Museum, F.A. 208.

159 *Peace – burial at sea.* Exh. RA 1842. Oil $34\frac{1}{2} \times 34\frac{1}{2}$. Tate Gallery, London, 528.

160 *Snowstorm* 1842. Exh. RA 1842. Oil 36×48. Courtesy of the Trustees of the National Gallery, London, 530.

161 *Shade and darkness* 1843. Exh. RA 1843. Oil $30\frac{1}{2} \times 30\frac{1}{2}$. Tate Gallery, London, 531.

162 *Rain, Steam and Speed.* Exh. RA 1844. Oil $35\frac{3}{4} \times 48$. Courtesy of the Trustees of the National Gallery, London, 538.

163 *Light and colour (Goethe's Theory)* 1843. Exh. RA 1843. Oil 31×31. Tate Gallery, London, 554.

164 *War: The exile and the rock limpet* 1842. Exh. RA 1842. Oil 31×31. Tate Gallery, London, 529.

165 *Red Righi* 1841. Watercolour $11\frac{3}{4} \times 18$. National Gallery of Victoria.

166 *Funeral at Lausanne* 1841. Watercolour $9\frac{1}{4} \times 13$. British Museum, CCCXXXIV p. 2.

167 *Coblenz* 1844. Watercolour $9 \times 12\frac{7}{8}$. British Museum, CCCLII p. 19.

168 *Figures in a storm c.* 1830. Watercolour $13\frac{3}{4} \times 19\frac{3}{4}$. British Museum, CCCLXV 25.

169 *Coach at Eu* 1845. Watercolour $9 \times 12\frac{3}{4}$. British Museum, CCCLIX p. 1.

170 *Interior of church* 1845. Watercolour $12\frac{3}{4} \times 9$. British Museum, CCCLIX p. 7.

171 *Whalers* 1845. Exh. RA 1845. Oil 35×47. Tate Gallery, London, 545.

172 *The Angel standing in the sun* 1846. Exh. RA 1846. Oil $30\frac{1}{2} \times 30\frac{1}{2}$. Tate Gallery, London, 550.

173 *Undine giving the ring to Masaniello* 1846. Exh. RA 1846. Oil $30\frac{1}{2} \times 30\frac{1}{2}$. Tate Gallery, London, 549.

174 *Skeleton falling off a Horse c.* 1830. Oil $23\frac{1}{2} \times 29\frac{3}{4}$. Tate Gallery, London, 5504.

175 *Hero of a Hundred Fights* 1846. Exh. RA 1847. Oil $35\frac{3}{4} \times 47\frac{3}{4}$. Tate Gallery, London, 551.

176 *The visit to the tomb* 1850. Exh. RA 1850. Oil 36×48. Tate Gallery, London, 555.

Index

Page numbers in italic refer to plates